BURNE·JONES

DEBRA N. MANCOFF

Pomegranate

SAN FRANCISCO

Published by Pomegranate
Box 6099, Rohnert Park, California 94927

Pomegranate Europe Ltd.
Fullbridge House, Fullbridge
Maldon, Essex CM9 4LE, England

FRONT COVER

The Days of Creation: The Sixth Day

1870–1876. Watercolor, gouache, shell gold and platinum paint
on linen-covered panel. 40¼ x 14³⁄₁₆ in. (102.3 x 36 cm).
Courtesy of the Fogg Art Museum, Harvard University Art
Museums, Bequest of Grenville L. Winthrop

Library of Congress Cataloging-in-Publication Data
Mancoff, Debra N., 1950–
Burne-Jones / Debra N. Mancoff.
p. cm.
Includes bibliographical references.
ISBN 0-7649-0615-1 (pb : alk. paper)
1. Burne-Jones, Edward Coley, Sir, 1833–1898. 2. Painters-
England-Biography. I. Title.
ND497.B8M36 1998
759.2-dc21
[B] 97-43406
CIP

Pomegranate Catalog No. A935
Designed by McEver Design, San Francisco
First Edition
05 04 03 02 01 00 99 98 8 7 6 5 4 3 2 1
Printed in Hong Kong

Note to the Reader:
Except where noted, the works illustrated in this book are by
Edward Burne-Jones. Dimensions are provided in inches and cen-
timeters; height precedes width.

CONTENTS

ACKNOWLEDGMENTS

Many people graced this project with their assistance and encouragement, and I would like to take the opportunity to thank them. At Pomegranate, Thomas F. Burke gave me strong initial support, and Katie Burke guided me through the project with insight and enthusiasm. I also thank Phil Freshman, who edited the manuscript with good sense and good humor, and Judy Johnson, who obtained the pictures and permissions to reproduce them. My gratitude goes as well to the Newberry Library in Chicago—with special thanks to Frederick E. Hoxie, Vice-President for Research and Education—for the Newberry Library/British Academy Scholars Exchange Award that supported my research in the United Kingdom in 1996 and 1997 and for welcoming me into its community as a Newberry Library Scholar in Residence.

Without access to the archives and collections of art galleries, museums, and private collections, a book of this kind could not be written. I want to thank my colleagues for sharing their knowledge and giving me their assistance. I am particularly grateful to: Christopher Ridgway at Castle Howard, York; Ronald Parkinson at the Victoria and Albert Museum, London; Robin Hamlyn at the Tate Gallery, London; Véronique Gunner at Sotheby's, London; Brian Allen, Steven Parissien, and Emma Lauze at the Paul Mellon Centre for Studies in British Art, London; Miriam Stewart, Mary Ann Trulli, and Jill Grossman at the Fogg Art Museum, Harvard University Art Museums, Cambridge; Anselmo Carini, Martha Tedeschi, and Mark Pascale at the Art Institute of Chicago; Kenneth Cain at the Newberry Library, Chicago; and Carmen T. Ruiz-Fischler and Hiromi Shiba-Lecompte at the Museo de Arte de Ponce, Puerto Rico. I also want to thank those institutions that granted Pomegranate permission to reproduce works from their collections.

Amy E. Henderson, Shelly Roman, and Philip Mancoff gave research assistance. I also want to thank Linda K. Hughes, Julie F. Codell, Karen Fullett, and Sarah Kennedy for discussing the project with me as it progressed. Gratitude also goes to Jody Lamb for supplying me with books that otherwise would have been hard to find. I deeply appreciate the continuing enthusiasm and encouragement of my parents, Philip and Elinor R. Mancoff; their goodness and patience have always played an essential role in the support of my work.

Finally, I must share with my readers the fact that Burne-Jones distrusted biographers. He believed that an artist's work, rather than words about his life, offered the truest account of his history. In writing this book, I have sought to respect that belief; and I was guided by Burne-Jones's own description of how he interpreted the works of Geoffrey Chaucer: "Not once have I invaded his kingdom with one hostile thought."

D. N. M.

Chicago, November 1997

INTRODUCTION

"I mean by a picture, a beautiful romantic dream of something that never was, never will be, in a light better than any light that ever shone, in a land no one can define or remember, — only desire." *Edward Burne-Jones*

Edward Burne-Jones (1833–1898) defied the conventions of his own age. The standards in which Victorian England placed its stock—progress, fortune, and fame—meant nothing to him. A dreamer and a romantic in a prosaic and materialistic world, he sought to transcend the limits of mundane reality by creating a rarefied realm of beauty in his art. Whether selecting subjects from chivalric lore or classical legend, fairy tale or fantasy, every picture Burne-Jones painted took him on a journey through the land of his dreams.

His road to recognition was unorthodox and self-determined. He left Oxford University one term short of completing a degree in theology to become a painter in London. He disdained traditional academic training, preferring to ally himself with the painters of the progressive Pre-Raphaelite circle, looking to the past for his inspiration. Yet he never fully accepted their dedication to realism and their meticulous attention to nature. In his art he served only one master, the vision he held in his imagination.

In 1877, after working for almost two decades in relative obscurity, Burne-Jones captured the attention of the Victorian art world with his debut exhibition at London's Grosvenor Gallery. His scope and mastery astonished the public and critics alike. He rose to prominence as one of the most admired and influential painters in England, but he never strayed from the path he had chosen as an emerging young artist: to portray the graceful, mysterious, and often fragile vision of an alternative realm that existed only in poetry and legend, where grace, glory, and romance dignified the soul and elevated the spirit.

In the midst of the critical acclaim and international recognition that came to him late in his career, Burne-Jones guarded his privacy and continued to set his own standards, claiming, "I need nothing but my hands and my brain to fashion myself a world to live in that nothing can disturb." His was a gentle and personal rebellion, but his impact was wide-ranging and enduring, shaping the aspirations of artists as disparate as Aubrey Beardsley, Fernand Khnopff, Stanley Spencer, and the young Pablo Picasso. Standing apart from his time, he produced a legacy of timeless work. With only an elusive goal to guide him, the beauty he defined as "the other side of truth," his dedication reflected the convictions of the legendary medieval knights he so admired. Edward Burne-Jones pursued his singular vision as if on a quest, never questioning, never straying from the path he believed was his destiny.

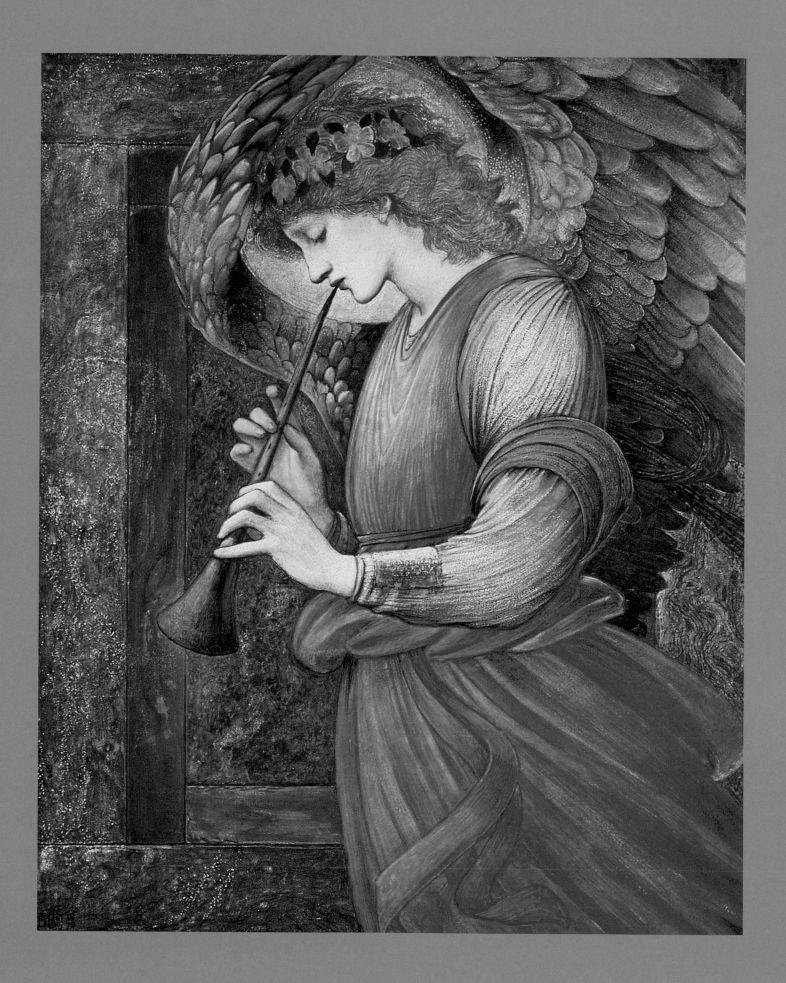

THE JOURNEY BEGINS

Edward Coley Burne-Jones was born in Birmingham on August 28, 1833.* His birth brought new hope to Edward Richard Jones and Elizabeth Coley, whose first child, a daughter, did not survive infancy. Jones earned a meager living making carved and gilded picture frames, and, in anticipation of a brighter future, he and Elizabeth had moved into a new two-story house on Bennett's Hill with a showroom and workshop on the ground floor to accommodate his business (Figure 1). But the couple's joy was brief: Elizabeth died within a week of the baby's arrival. Jones

sank into an enduring grief that was to haunt the relationship between father and son

The cramped residence was situated on a commercial street between two thoroughfares in the heart of a vigorous city. During the eighteenth century the Industrial Revolution had transformed Birmingham, with its rich nearby deposits of iron and coal, from a quiet Midlands market town into a major manufacturer of iron, steel, and copper products. Known as the "workshop of the world," Birmingham boomed with relentless activity. On a brief visit in the early 1830s, the social philosopher Alexis de Tocqueville marveled at the energy of a population that worked "as if they must get rich by evening and die the next day." But Jones possessed little ambition. His quiet old-fashioned shop, crowded with

frames and mirrors, supported a modest life with little to spare.

Jones needed a nurse to care for his infant son, whose low birth weight and fragile respiratory system seemed to predict an invalid's future. One after another proved to be incompetent. Finally, on the recommendation of a family friend, he hired a Miss Sampson, an uneducated but pious woman who proved to be a devoted foster mother and who ran the frugal household as if it were her own. Little Edward's health improved under her care, but his constitu-

* As a boy and through his student days, the artist was known by his father's surname, Jones. Sometime during the late 1850s, he added Burne, the married name of his paternal aunt and godmother, Katurah Jones Burne. The hyphen was officially inserted in 1894, at the insistence of his son, Philip, when the government made the artist a baronet. For clarity, the artist is called Edward in this chapter (to distinguish him from his father) and, in subsequent chapters, Burne-Jones.

tion remained delicate. Regular visits to relatives in the country—to give the boy the benefits of fresh air—further strained the family budget. While Miss Sampson responded to the boy's physical needs, she was bewildered by his long, introspective silences. When she demanded to know what was on his mind, he teased her with the nonsensical response "Camels."

Growing up in straitened circumstances taught Edward to trust his own resources. Although he described himself in childhood as "Unmothered, with a sad papa, without brother or sister, always alone," he never recalled feeling lonely or deprived: "I was always drawing." His precocious talent—by age five he was sketching recognizable portraits—was not particularly cultivated, but it was not discouraged. It was simply accepted as part of the boy's inward nature.

It is uncertain who taught Edward to read and write, but by the time he was nine he was penning long letters from the country to his father. As for reading, there were few books in the house on Bennett's Hill; most of

Figure 1, Drawing of the House in Bennett's Hill, from Georgiana Burne-Jones, *Memorials of Edward Burne-Jones* (London: 1904). F. L. Griggs photo courtesy of The Newberry Library, Chicago.

these contained poetry. Jones occasionally composed sentimental verse, but he did not approve of novels. Edward took interest in only one book, a volume of Aesop's fables. In a letter from the country, after enthusiastically describing swims and donkey rides, he confessed that he missed his favorite book. "I only wish you could send me Aesop's Fables," he wrote, "but I suppose you cannot." Edward was enchanted by the fables' portrayal of animals speaking and acting as if they were human. Like drawing, reading presented a road away from reality into a realm of wonder.

In 1844 Jones enrolled eleven-year-old Edward in the English course at King Edward's Grammar School in Birmingham. Tuition was free; pupils paid only for their books. The English, or "Commercial" course as it was known, stressed the study of Latin (in contrast to the Classical course, which also required Greek) and was regarded as good training for a business career. As many as 450 pupils attended the day school, crowding into two noisy second-floor rooms, above the din of Birmingham traffic; absolute concentration was re-

quired to learn anything at all. Edward entered timidly, describing himself later as "the kind of little boy you kick if you are a bigger boy." Over time, however, he managed to thrive in the pandemonium.

For young Edward, education meant the opportunity to read without restriction. School also forced him to shed some of his natural reticence. Still, it was three years before he made his first close friend, classmate Cormell Price. They shared a love of heroic literature, spending their free hours together reading the eighteenth-century Scottish writer James Macpherson's Ossian poems, the novels of Sir Walter Scott, and old English poems and ballads. Romantic ambitions shaped their plans. They outlined an imaginary curriculum for a "Universal history for students" and gathered objects for a "museum" to be stocked with the curiosities, including fossils, minerals, shells, and "a piece of the stone which was erected on Bosworth Field on the spot where Richard the 3rd was slain."

During his years at school, Edward continued to draw, using spare moments to make caricatures of his schoolmasters and cartoons of devils playing cricket and other games. He astonished classmates by holding up his end of a conversation while covering sheets of foolscap, able to give equal attention to both activities. In 1848 he added three evening sessions a week at the Government School of Design to his studies. But he failed to impress his instructor, Thomas Clarke, who suggested that the boy "Might do better if he exhibited more industry." Since Clarke also served as drawing master at King Edward's, it is hardly surprising that during his time there the boy earned only one prize for art. His academic performance, on the other hand, won him recognition. Within just three years, he advanced from the eighth to the first class and was named the school's top-ranking student.

Along with his schoolmaster caricatures, Edward mercilessly lampooned figures of the clergy. But he also repeatedly drew sensitive images of a robed priest at an altar. Classmate Richard Watson Dixon recalled his surprise when Edward showed him one of these drawings and told him, "That is what I hope to be some day." Prior to this time Edward had evinced little interest in religion, finding Miss Sampson's dogmatic morality stultifying, his father's church ugly, and the family pastor a deserving target of ridicule. Although introspective, Edward was hardly pious; in fact, at school he was known as a prankster. His new ambition stemmed more from romantic idealism than from religious conviction: He had fallen under the spell of the Oxford Movement.

In the early 1830s three Oxford clergymen, John Henry Newman (1801–1890), John Keble (1792–1866), and Richard Hurrell Froude (1803–1836), began a campaign to revitalize the Church of England through a restoration of selected Roman Catholic doctrines and rites. Newman published a series of pamphlets, Tracts for the Times (1833–1841), promoting this reformed Anglicanism as a plausible middle path between Catholicism and evangelicalism. The movement stirred considerable controversy, leading Newman to convert to Catholicism in 1845 and leave Oxford the next year. But his cleric followers dispersed throughout England, carrying on his ideas. Known as Anglo-Catholics, they brought to their parishes a heightened emphasis on ritual, with enriched vestments, solemn

processions, and elaborate church furnishings. A visit to Hereford Cathedral in 1849 introduced Edward to Newman's reforms. The beauty of this medieval church and the theatricality of the service he attended set off his yearning for a clerical career.

Also in 1849, Edward switched from the English to the Classical program at King Edward's, concentrating on history and Greek and making rapid progress. He wrote long letters to relatives proclaiming his religious opinions, but his deliberate use of arcane syntax—as well as the conceit of signing himself "Edouard Cardinal de Byrmyngham"—reveals that his fascination was more for the trappings of ancient ritual than for modern theological ideas. Jones eagerly supported his son's new calling. To extend his income, he rented out the residential rooms of the Bennett's Hill house as offices, keeping only the showroom and workshop for his own use. He and Miss Sampson moved into a small residence at the edge of the city. Jones had a long walk to work each day, and he had to take in a boarder. But by 1852, when Edward received his certificate of matriculation from King Edward's Grammar School, Jones was ready to send his son to Oxford at his own expense.

Figure 2, William Morris at age twenty-three. Black-and-white photograph by Emery Walker. Courtesy of the National Portrait Gallery, London.

Early in 1853, Edward left Birmingham for the "city of his hopes." Oxford University, founded in the twelfth century, appeared to Edward as a living vision of his beloved Middle Ages. In a letter to his father, he described Oxford as a "glorious place; . . . godlike," with "majestic" dons who overflowed "with generosity and good nature." His first moonlit walk through the colleges convinced him "it would be heaven to live and die there."

The reality of college life, however, failed to match the romance of its setting. Lacking Cardinal Newman's powerful presence, the Oxford Movement had lost its hold on the campus. A housing shortage forced Edward to take rooms outside Exeter, his home college, for the first two terms. And two former King Edward's classmates—Richard Watson Dixon and William Fulford—enrolled at Pembroke College rather than Exeter. Now disillusioned with his choice of school, Edward felt increasingly alienated and lonely.

He soon discovered another Exeter student who shared his disappointments. During the first term, Edward introduced himself to William Morris (1834–1896), the man who had sat next to him during entrance examinations.

Like Edward, Morris was enthralled with the romantic piety of the Oxford Movement and had begun studying theology in order to pursue a clerical career. Within a few short weeks, they established a friendship that would endure for the rest of their lives. Morris came from a wealthy family in Walthamstow, a north London suburb on the edge of Epping Forest. Generous with his large allowance, he offered to pay Edward's expenses. When Edward refused, Morris bought them books to share, starting a lifelong habit; Morris read aloud while Edward filled sheets of paper with sketches.

Together they read the Oxford Movement texts, Newman's *Tracts for the Times* and Newman and Froude's *Lyra Apostolica* (1836). Their shared taste for romance and mystery led them to the contemporary writings of Edgar Allan Poe. For the Middle Ages, they chose the provocative works of Kenelm Henry Digby, whose *Broadstone of Honour: or, Rules for the Gentlemen of England* (1822–1823) advocated the revival of chivalry in modern masculine behavior. Their favorite new novels—Charles Kingsley's *Yeast* (1851) and Charlotte Yonge's *The Heir of Redclyffe* (1853)—featured self-sacrificing young heroes motivated by a sense of noblesse oblige. Morris introduced Edward to the poems of Alfred Tennyson (1809–1892). The poet's enthusiastic portrait of "Sir Galahad" (1842), the chaste young knight of King Arthur's Round Table who sought the Holy Grail, inspired Edward to write to Cormell Price back in Birmingham: "I have my heart set on our founding a brotherhood. Learn Sir Galahad by heart. He is to be the patron of our Order."

Edward and Morris's passion for medieval art rapidly surpassed their fervor for modern religion. The newly restored Merton College Chapel, with its stained-glass windows and painted ceiling, and the New College Cloisters were their "chief shrines in Oxford." At the Bodleian Library they inspected illuminated manuscripts and cultivated their mutual love of the work of Geoffrey Chaucer. Edward adopted Morris's fascination with historic sites; a "pilgrimage" to the ruins of Godstowe Abbey in 1854 to see the grave of Fair Rosamund—the illicit lover of King Henry II—made him feel so "wild and mad" that he had to throw stones in the water to return to reality. Writings by the art critic and social theorist John Ruskin (1819–1900)—particularly the multivolume books *Modern Painters* (1843–1860) and *The Stones of Venice* (1851–1853) as well as *The Seven Lamps of Architecture* (1849)—replaced the Oxford Movement tracts in shaping their beliefs.

Although twins in spirit, the two friends were a study in physical contrasts. Morris was short and stocky, with such thick brown curls that Edward called him Topsy. He possessed high energy and an explosive temperament. Edward was tall and slender, with lank, almost colorless hair. Still physically fragile, his quiet demeanor contrasted with Morris's gregariousness. But both shared a mischievous nature and a love of horseplay and practical jokes. Although beginning in their second year they had lodgings at Exeter College, they spent idle hours at Pembroke College with Dixon, Fulford, and Charles Faulkner, who also was from Birmingham. In 1854 these five were joined by Cornell Price and another former King Edward's Grammar School student, Harry Mac-

Dante Gabriel Rossetti

Figure 3, WILLIAM HOLMAN HUNT (English, 1827–1910),
1882–1883 (replica of a drawing made in 1853). Oil on wood
panel, 11⅞ x 9 in. (30.2 x 22.9 cm) (within oval shape).
Birmingham Museums and Art Gallery.

European Old Masters. They revered earlier art, work of the fourteenth and fifteenth centuries, art before the time of Raphael. Believing that contemporary work expressed an artificiality in its drama and sentiment, the Pre-Raphaelite Brotherhood swore instead to "have genuine ideas to express," "to study Nature attentively," and "to sympathise with what is direct and serious and heartfelt in previous art." Their association was brief; by 1853, the brothers had all gone in separate directions. But their meticulously detailed paintings, distinctive for their jewel-toned colors, high-minded subjects, and an archaizing aesthetic, provided an alternative to the staid conventions of the English art world.

Edward first encountered the aims of the Pre-Raphaelites through words rather than pictures. Morris read to him Ruskin's lectures on architecture and painting, delivered at the University of Edinburgh in 1853 and published as a set in 1854. The critic's description of Rossetti's works so moved Edward that for days he and Morris "talked of little else but paintings which we had never seen." But soon he secured a copy of *The Germ*—a short-lived journal of poetry, essays, and illustrations published by the Brotherhood in 1850—and he saw Millais's *The Return of the Dove to the Ark* (1851) in a local picture gallery.

Increasingly, Edward turned away from the university to satisfy his imagination. At the end of spring term in 1855, he traveled to London to view the Pre-Raphaelite paintings—works by Hunt, Millais, and Ford Madox Brown (1821–1893)—in the Royal Academy's summer exhibition. But elsewhere, he saw a watercolor by Rossetti, who never participated in the Academy shows, and it left a greater im-

donald. The group became known as the Pembroke set.

In their romantic enthusiasm, Edward's circle resembled the Pre-Raphaelite Brotherhood, a band of painters and poets formed in London in 1848. Its members—including William Holman Hunt (1827–1910), John Everett Millais (1829–1896), and Dante Gabriel Rossetti (1828–1882)—were young, disaffected art students. They challenged the strictures of contemporary academic art training and rejected the prevailing aesthetic canon, which was based on examples from the classical antique and

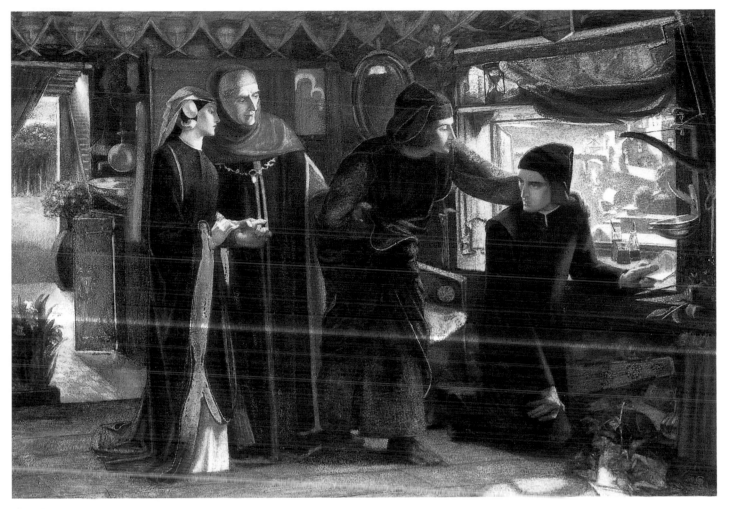

Dante Drawing an Angel on the First Anniversary of the Death of Beatrice

Figure 4, DANTE GABRIEL ROSSETTI (English, 1828–1882), 1853. Watercolor on paper,
16½ x 24 in. (42 x 61 cm). Ashmolean Museum, Oxford.

pression. *Dante Drawing an Angel on the First Anniversary of Beatrice's Death* (1853; Figure 4)—a tensely emotional depiction of the grieving poet clutching a drawing he made in remembrance of his lost love—confronted Edward with a startling new aesthetic. The elongated figures, confined composition, and saturated tones blended the beauty of medieval art with modern expression. Rossetti's work met the expectations Edward held after reading Ruskin. From then on he regarded Rossetti as "the chief figure in the Pre-Raphaelite Brotherhood."

In July he set off with Morris and Fulford on a cathedral tour of northern France. Once again, Ruskin was their guide. The essay "On the Nature of Gothic" in *The Stones of Venice* prepared them to view the ancient monuments as primitive and romantic, evidence of a more savage yet more mystic age. Edward was enthralled with the soaring structures at Amiens, Beauvais, and Chartres. There were other wonders for Edward as well; these ranged from seeing Fra Angelico's altarpiece *Coronation of the Virgin* (1435–1436) in the Louvre to hearing his first opera,

Giacomo Meyerbeer's *Le Prophète* (1849). By the end of the tour, both Edward and Morris resolved to "begin a life of art." With no regrets, Edward relinquished his ambition to join the clergy in favor of becoming a painter. He remembered the moment as "the most memorable night of my life."

This decision, although profound to Edward, hardly surprised his friends. Edward was always drawing, no matter what was going on around him. Among those intrigued by his habit was Archibald Maclaren, owner of an Oxford gymnasium where the members of the Pembroke set took fencing lessons. An amateur scholar of mythology, Maclaren had written a book of fairy tales, *The Fairy Family*, and he hired Edward to draw illustrations. The earliest designs, made in 1854, betray the anecdotal influence of popular illustrators such as George Cruikshank and "Dicky" Doyle. But in 1855, Edward saw Rossetti's illustration for William Allingham's poem "The Maids of Elfenmere" (Figure 5), part of the suite "Night and

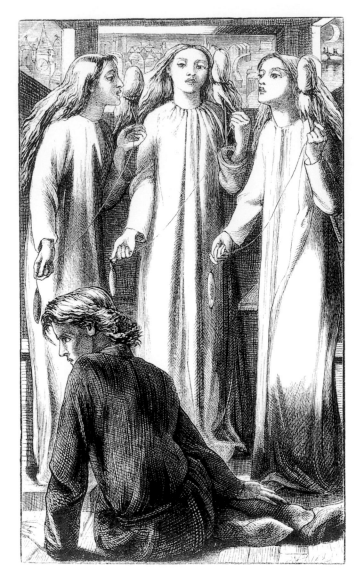

"The Maids of Elfenmere"

Figure 5, DANTE GABRIEL ROSSETTI (English, 1828–1882), illustration from the poetic suite "Night and Day Songs" in William Allingham, *The Music Master* (London: 1855). Photograph courtesy of The Newberry Library, Chicago.

Day Songs" in the newly published collection *The Music Master.* Calling it "the most beautiful drawing for an illustration I have ever seen," he transformed his own style in response. His new designs for *The Fairy Family* mirrored Rossetti's aesthetic of tense, controlled lines and minute rendering of details that emphasized emotion over anecdote (Figure 6). The earlier illustrations now embarrassed him; to Maclaren's disappointment, Edward abandoned the project.

Edward spent the Christmas holidays in Birmingham with his father and, in the new year, visited his Aunt Katurah in London. When he discovered that Rossetti gave lectures at the Working Men's College, an open university that had been established by the educator and social reformer Frederick Denison Maurice in 1854, he attended, hoping to catch a glimpse of the man he so admired. He asked an acquaintance, Vernon Lushington, to alert him when Rossetti entered the hall. Lushington did more than that;

a few nights later, he invited Edward to join a small gathering in his rooms. Rossetti was there, and, by evening's end, Edward arranged to visit his studio. Generous with his time to a young man he would later describe as "one of the nicest young fellows in Dreamland," Rossetti gave Edward a tour of his disorderly work space, displaying his current designs and even allowing him to watch him work, a privilege he rarely granted.

Edward returned with reluctance to Oxford in February 1856. Morris had already left the university, taking a pass degree and securing an apprentice position in the office of the Oxford Gothic Revivial architect G. E. Street. Both men continued their close association with the Pembroke set. The group collaborated to publish a small journal, influenced by *The Germ.* Called the *Oxford and Cambridge Magazine,* it was funded mostly by Morris and edited by Morris and Faulkner. It featured original poems and short stories (marking Morris's debut as a writer) as well as critical reviews of the arts and literature. Edward contributed a few stories, but most telling was his essay on William Makepeace Thackeray's *The Newcomes*

Figure 6, Illustration for Archibald Maclaren's *The Fairy Family,* 1854–1856. Pen and ink, 12 x 12 in. (30.5 x 30.5 cm). Courtesy of Sotheby's, London.

(1853–1855), a novel about a young man who shuns his family's social advantages to pursue a life as an artist. Edward expressed great sympathy for Clive Newcome, whose father cannot see anything more than "refined *dilettantism*" in his son's future. Jones's own response to his son's recent career decision was never recorded, but in describing the message of the novel, Edward conveys the raw ache of personal experience:

Respectability? When shall we waken from the nightmare and dream of phantoms to a knowledge of the true dignity of work in any kind; to a confession of the majesty of soul in any form? I wish that the primal question at the setting out of life were not what is the best thing to do, and the most thought of, but rather how and in what manner and degree of excellence it is to be done.

Despite his father's considerable financial sacrifice, Edward left the university in May—one term short of taking his pass degree. Oxford had nothing more to offer him; the pursuit of his dreams now called him to London.

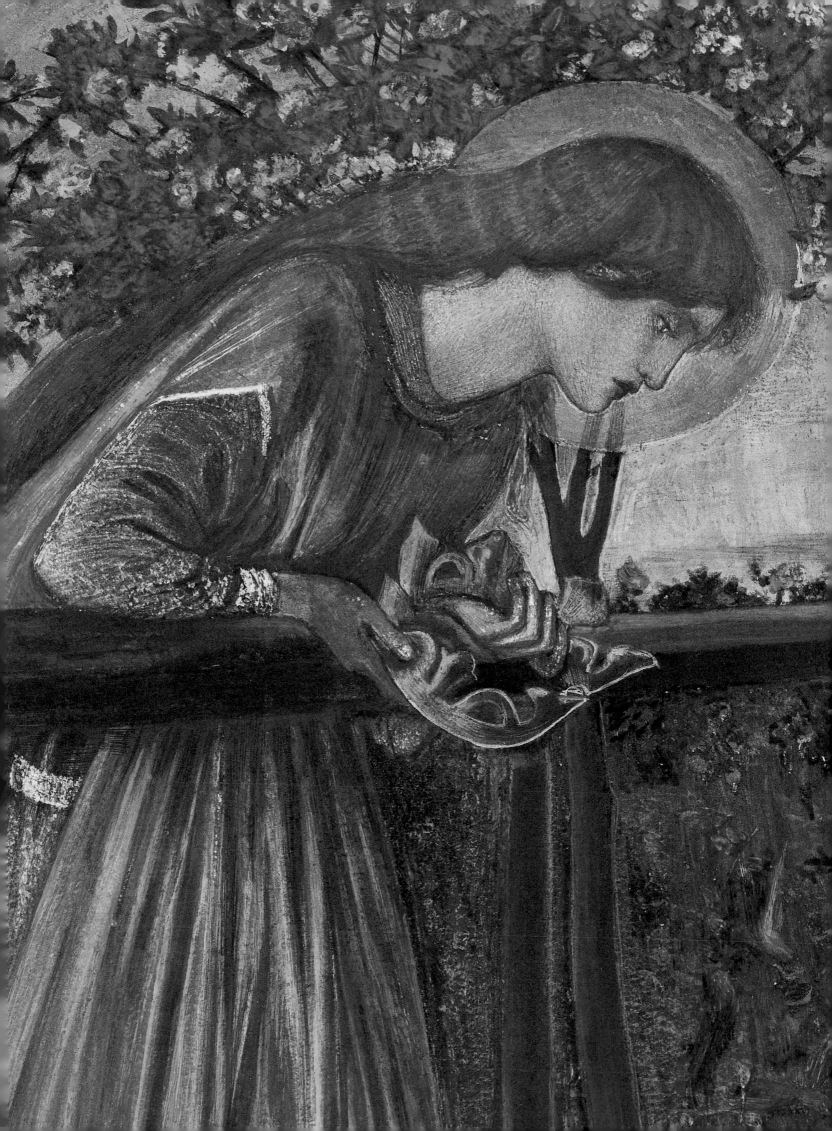

CHASING THE DREAM

Armed with the innocence and enthusiasm of a novice knight embarking on his first quest, Burne-Jones left his safe circle of friends in Oxford to pursue an artist's life in London. He had no course of training in mind, no practical tactics, no promise of commissions. His goal loomed larger than his plans for achieving it. In May 1856, when Burne-Jones moved into solitary rooms in Chelsea, he was untried as a painter, but he sought to transform himself into an artist on the strength of conviction. Once again, he placed his trust in the power of his imagination to make his dreams his destiny.

Rossetti proved to be a worthy mentor and friend. Only five years older than Burne-Jones, he had already established a position in the London art world built equally on recognition and notoriety. He shunned the popular exhibition venues, such as the Royal Academy, but his highly individualistic style—marked by crowded compositions, a disregard of conventional standards of beauty, and the choice of arcane and often obscure subjects—drew attention from figures as diverse as Alfred Tennyson and John Ruskin. He voiced outrageous opinions and ignored the decorous behavior expected of a successful artist, preferring a life of free-spirited bohemianism. Touched by Burne-Jones's earnest aspirations—as well as by his unrestrained admiration—Rossetti welcomed him into his circle and squired him to art exhibitions and literary gatherings. Although Burne-Jones was shy about showing Rossetti his work, Rossetti lavished praise on his protégé's promised potential and gave him the affectionate nickname Ned.

Nourished by Rossetti's encouragement and stimulating company, Burne-Jones gained the confidence to show him his sketches for critical suggestions. Under Rossetti's unstructured tutelage, he also acquired basic technical skills in painting. Although he supplemented these informal lessons with irregular attendance at life-drawing classes at the historical painter J. M. Leigh's academy, Burne-Jones remained largely self-taught. Rossetti urged him to trust his own aesthetic sense, warning that conventional training with its standards derived from the study of classical antiquities—would stunt

a young artist's individuality. Burne-Jones saw Rossetti's influence as essential to his artistic growth: "He taught me to have no fear or shame of my own ideas, to design perpetually, to seek no popularity, to be altogether myself."

During the summer of 1856, Morris visited Burne-Jones almost every weekend. In August he negotiated a transfer from the headquarters of G. E. Street's architectural firm in Oxford to its branch office in London. The two friends found lodgings together in the Bloomsbury district, but there was not enough space to accommodate Burne-Jones's studio. In November they moved into unfurnished rooms Rossetti had once occupied at 17 Red Lion Square. Morris soon lost interest in his architectural career and, with Rossetti's encouragement, left his position to devote himself to art.

The romantic enchantment with the Middle Ages that had formed the basis of their friendship at the university now shaped Burne-Jones's and Morris's shared artistic goals in London. While Morris tried to become a visual artist through hard work and force of will, writing came as naturally to him as drawing did to Burne-Jones. His poems and tales of chivalric adventure, in turn, inspired Burne-Jones to concentrate on images of knights and ladies, and their work developed in synchronism, Burne-Jones sketching while Morris read aloud. Always more outspoken and

Working in Red Lion Square

Figure 7, from Georgiana Burne-Jones, *Memorials of Edward Burne-Jones* (London: 1904). Photo courtesy of The Newberry Library, Chicago.

articulate than Burne-Jones, Morris formulated an objective for their efforts: to revive the high standards of individual craftsmanship that he believed had existed in the pre-industrial world.

Furnishing the rooms at 17 Red Lion Square gave Morris an immediate opportunity to begin pursuing that goal. He hired a cabinetmaker to construct a massive table, colossal chairs, and a large settle, complete with bench seating and built-in cupboards (Figure 8). The furniture was blunt and rough-hewn, crowding their already cramped quarters, which one visitor described as a "noble confusion"—filled with armor, remnants of tapestry, swaths of drapery, and unfinished sketches and paintings. Delighted with the medieval scale and simplicity of the handcrafted pieces, Burne-Jones declared: "When we have painted designs of knights and ladies upon them they will be perfect marvels."

The broad, plain surfaces of Morris's early furniture preserve Burne-Jones's first experiments in painting. His style, as seen on the *Prioress's Tale Wardrobe* (1859; Plate 2), was dense, decorative, and self-consciously medieval. The subject, derived from one of Chaucer's *Canterbury Tales*, is a Christian boy whose constant singing in praise of the Virgin Mary so angers the men of his city's Jewish quarter that they slit his throat and throw him into an open sewer. Burne-Jones gives no indication

Topsy and Ned on the Settle

Figure 8, MAX BEERBOHM (English, 1872–1956), from *Rossetti and His Circle* (London: 1922).
Photo courtesy of The Newberry Library, Chicago.

of this grisly sacrifice in his narrative. On the wide panel, he depicts the Virgin rewarding the boy with a miraculous grain; placed beneath his tongue, it allows him to continue singing until his body is found and can receive a proper burial. On the narrow panel, the Virgin appears again. Surrounded by ranks of angels, she is ready to receive the boy in heaven. Presenting the miracle rather than the martyrdom, Burne-Jones set a lifelong pattern of interpretation: to extract beauty and mystery from even the harshest of subjects.

Although Burne-Jones fully enjoyed decorating Morris's furniture, during the early years of his career he clearly preferred drawing to painting. His choice was, in part, practical; oil paints and canvas were expensive, and the smell of

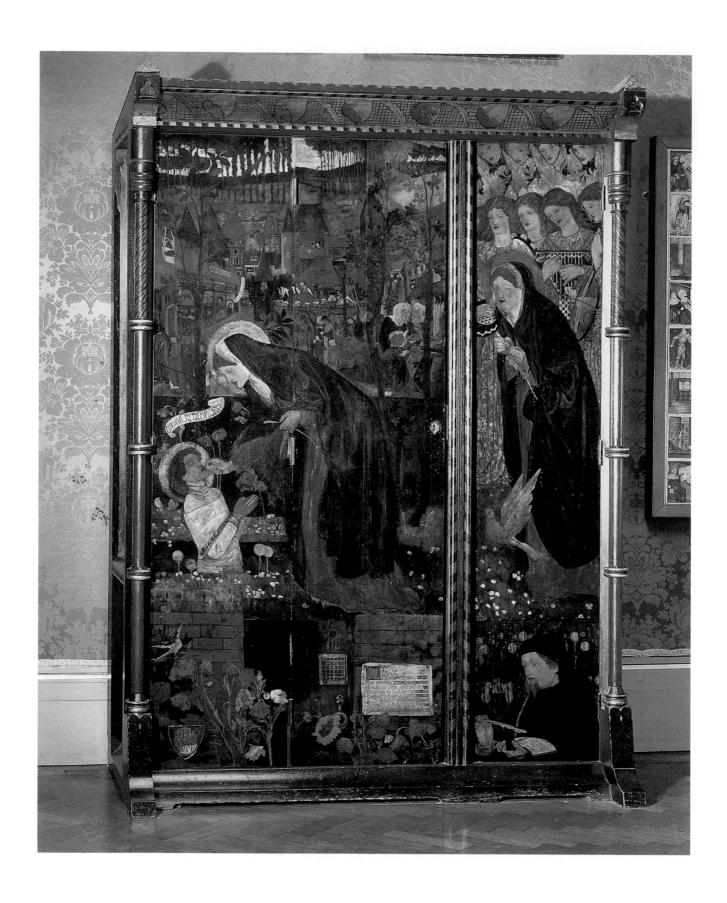

Prioress's Tale Wardrobe

Plate 2, PHILIP WEBB, designer (English, 1831–1915), 1859. Ashmolean Museum, Oxford.

turpentine made him nauseous. But also, the small scale of drawings and his practiced hand enabled him to attain a mastery that he had yet to achieve in painting. By 1857 he began working in pen-and-ink. In this he emulated Rossetti, who favored that medium at the time. His method of softening tautly rendered lines by working the surface with a penknife reveals his familiarity with a technique Ruskin advocated in his book *Elements of Drawing* (1857). Ruskin also urged his readers to study the engravings of Albrecht Dürer, and the rich tonality—as well as the recurring motifs—of Burne-Jones's drawings suggest that he followed this advice.

His subjects explored subtle variations on a single theme, his imaginative vision of the Middle Ages. *Going to the Battle* (1858; Figure 9), a pen-and-ink rendering on vellum of three women silently watching as their knights depart, is typical. Burne-Jones offers a poignant glimpse into a lost world distinctive for its rarified elegance and unearthly grace; the work reflects his most cherished fantasy: that in medieval days, chivalry and courtesy were the sources of beauty. His wife, Georgiana, later described these early drawings as a series of "designs and pictures that never

Going to the Battle

Figure 9, 1858. Pen and ink and gray wash on vellum, 6½ x 7½ in. (16.5 x 19 cm). Fitzwilliam Museum, Cambridge.

ceased as long as he lived."

Commissions for his work were slow to come, and, at first, his prospects for earning a living as an artist appeared limited. In 1856 Rossetti arranged for Burne-Jones to copy William Windus's painting *Burd Helen* (1856) on a woodblock for reproduction in the *Illustrated London News*. Copy work bored Burne-Jones; he never finished the job. Next, Rossetti got him an assignment producing designs for stained glass. The first one, *The Good Shepherd* (1857), was later made into a window for a church in Maidstone by the London firm James Powell and Son. The work suited him, and as other commissions followed, Burne-Jones was able to rely upon stained-glass designs as a stable source of income. He produced the drawings at night, often while entertaining guests, sketching as effortlessly as he had at school.

In March 1857, Burne-Jones secured his first painting commission. Thomas E. Plint, a Leeds stockbroker, allowed him to select his own subject. Inspired by Rossetti's 1847 poem "The Blessed Damozel," Burne-Jones proposed to portray a love that endured beyond death. He planned two images: the first of the earthly lover sadly wandering the

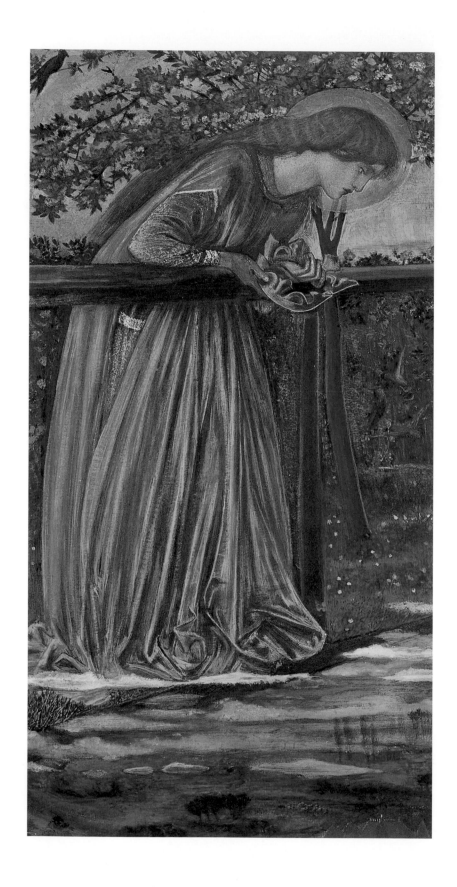

The Blessed Damozel

Plate 3, 1860. Watercolor and gouache on paper on linen, 15¾ x 8 in. (40 x 20.3 cm). Courtesy of the Fogg Art Museum, Harvard University Art Museums, Bequest of Grenville L. Winthrop.

bustling city streets; the second, a pendant image portraying the heavenly damsel leaning out from her celestial sphere to gaze upon her devoted suitor. Plint requested works in oil, but Burne-Jones abandoned an early attempt, completing instead a single watercolor, *The Blessed Damozel* (1860; Plate 3). The surface, its thickly worked pigment embellished with gold, demonstrates an unorthodox use of the medium that was to become a hallmark of Burne-Jones's work. He rejected the conventional translucence of watercolor for an opacity that resembled the tempera paint used by medieval manuscript illuminators.

Also in 1857, Burne-Jones faced the challenge of grand-scale painting for the first time. Early in the summer, Rossetti convinced the architect Benjamin Woodward to let him decorate the upper-story interior of the Oxford Union Society's new Debating Hall with murals. Woodward agreed to all of Rossetti's demands: to choose the artists, to choose the subject, and to exercise full artistic control over the project. Rossetti and his crew—a group of inexperienced artists, Burne-Jones and Morris among them—offered to work for free, asking only that the Society cover the costs of housing and materials. As a source for his subject, King Arthur and the Knights of the Round Table, Rossetti turned to Sir Thomas Malory's *Morte Darthur* (1469–1470), the canonical source for the medieval legend.

This theme and its source had deep significance for Burne-Jones and Morris. During the summer of 1855, after their trip to France, Morris visited Burne-Jones in Birmingham. Burne-Jones took his friend to his favorite bookshop to show him a treasure, an 1817 edition of *Le Morte Darthur*, edited by Robert Southey. The book was expensive, and Burne-Jones had been reading it bit by bit in the shop. Morris bought it for them to share. Georgiana Burne-Jones later reflected that "the book never can have been loved as it was by those two men." The chivalric adventures of the king and his knights, their passionate desires and their unwavering devotions, all told in Malory's epic but simple prose, provided a mythology for the two young artists' romantic medievalism. The Arthurian legend entered Burne-Jones's life as an emblem of friendship; it endured as a touchstone of his artistic vision to the end of his days.

Rossetti and his crew converged on Oxford in August 1857 to carry out the work they called the "jovial campaign." Valentine Prinsep (1838–1904), one of the younger artists, characterized the endeavor as hilarious fun, with constant pranks and "roars of laughter." The Society did not provide fees for models, so the artists combed Oxford for "stunners" and persuaded them to model for the heroines of the legend. They also sat for each other; Burne-Jones posed as an exhausted Lancelot for Rossetti's mural *Lancelot's Vision of the Sangreal*. Morris commissioned a local metalsmith to make a suit of armor, but when he tried it on, the helmet got stuck on his head. John Ruskin, a friend to both Rossetti and the architect, apologized for the artists' behavior: "You know the fact is they're all the least bit crazy and it is very difficult to manage them."

The murals were an artistic disaster. As a site for decoration, the design of the upper-story walkway, lined with bookshelves and pierced with windows, was ill-suited for painting. The artists, using distemper, painted on a fresh—

and slightly damp—whitewash laid directly over the new brick walls. Although the luminous color was widely praised during the course of the project, the steady absorption of paint into the walls rapidly made the work indecipherable. Few of the artists even finished their murals. Rossetti left two bays blank when he departed Oxford in November. These were filled in later by a local painter, William Riviere.

Working slowly and cautiously, Burne-Jones finished his mural in February 1858, long after the others had left. It depicted the enchantment of Arthur's wizard, Merlin, by Nimuë, the Lady of the Lake, Although the two large figures, draped in red, possessed the solemn grace of the knights and ladies in his miniature designs, the composition of the mural was loose and vacant. The mural fell far short of his expectations, but the challenge of designing on a large scale, the camaraderie of collaboration, and the power of the subject to stir his imagination all gave tangible form to his once vague desire for a "life of art."

Upon his return to London in March, Burne-Jones suffered a physical collapse. His ailments—exhaustion, fever, and respiratory congestion—were the same ones that had plagued him as a child. Despondent, he wrote to his old friend Cormell Price that his days were "horribly dull—such a jolly time seems to have gone away so completely. I wake up miserably every morning." This sense of depletion after an outburst of activity set a pattern that persisted for the rest of his life.

In the summer of 1858, Burne-Jones accepted an invitation for an extended stay with Valentine Prinsep's family at Little Holland House, their home in London's fashionable Kensington district. Prinsep's mother intended to nurse Burne-Jones back to health, but it was the stimulating company of the Prinseps and their friends that stirred him out of his torpor. The painter George Frederick Watts (1817–1904) was a long-term resident in the Prinsep home. Like Rossetti he welcomed Burne-Jones into his studio, gave him informal lessons, and became a lifelong friend. Ruskin, too, was a frequent visitor, and his exclamation on seeing the young artist's drawings—"Jones, you are gigantic"—led to the nickname Gigantic Jones. And, for a brief time, Alfred Tennyson, England's poet laureate, came to stay. His evening readings of the poems that would form the core of his Arthurian epic, *Idylls of the King* (1859), thrilled Burne-Jones. He described the poet as "the only guide worth following into dreamland."

An exquisite drawing captures the magic of this summer of growth and inspiration. *Sir Galahad* (1859; Figure 10), based on Tennyson's poem of 1842, depicts the knight as boyish and pensive. Burne-Jones pays homage to the poem in carefully rendered details: the "good blade" secured in the saddle's sheath, the "tough lance" cradled in the knight's right arm. Lost in quiet contemplation, Galahad rides past the men and women who indulge in sensual pleasures. He longs only for the satisfaction of the spirit; nothing can sway him from his quest to find the Holy Grail. But the strident boasting of Tennyson's knight—"My strength is as the strength of ten"—is absent in the serene youth portrayed by Burne-Jones. As delicate as a figure in a dream, this Galahad embodies the emerging artist's own sense of mission, fragile but enduring, trusting a personal vision on a quest into the unknown.

Sir Galahad

Figure 10, 1859. Pen and black ink on vellum, 6³⁄₁₆ x 7⁹⁄₁₆ in. (15.6 x 19.2 cm). Courtesy of the Fogg Art Museum, Harvard University Art Museums, Bequest of Grenville L. Winthrop.

OUR PALACE OF ART

On June 9, 1860, Edward Burne-Jones married Georgiana Macdonald (1840–1920). Georgie, as she came to be known, was the fifth child in the large family of the Methodist minister George Macdonald, who served in a church near Bennett's Hill in Birmingham from 1850 to 1853. Harry, the eldest of her two brothers, enrolled in King Edward's Grammar School, and the friendship he struck up with Burne-Jones there continued through their years at Oxford as fellow members of the Pembroke set.

In the memorial biography of her husband she wrote in 1904, Georgie recalled his first appearance in the Macdonald household, when she was but a "child in a pinafore." To her, he "looked a grown man." In the ensuing years, as the family moved to posts in London and then Manchester, Burne-Jones continued to visit, whether or not Harry was at home. His proposal of marriage in 1856 took her by surprise; he had seemed equally attentive to all five Macdonald sisters. With poor financial prospects—a novice artist could not support a family and a minister's daughter had a negligible dowry—they endured a typical Victorian long engagement, pledged to one another but postponing their wedding until their circumstances improved.

But despite the extended engagement, the decision to marry in the spring of 1860 was sudden, based more on changes in Burne-Jones's circle than on his growing financial stability. In 1859 Morris wed Jane Burden (1839–1914), the tall, brooding "stunner" who had posed as Guenevere for the Oxford Union murals. Rossetti married his longtime fiancée and model, Elizabeth Siddal (1829–1862), the following year; for almost a decade, her pensive features and abundant red hair set the unorthodox standard for Pre-Raphaelite beauty. In marrying Georgie, Burne-Jones acquired a mate rather than a muse. Practical and rather plain, she possessed a sharp intelligence, good sense, and a selfless nature.

Just prior to the wedding, Burne-Jones painted a pair of gouache portraits inspired by characters in Wilhelm Meinhold's story "Sidonia the Sorceress" (1847). *Sidonia von Bork* (1860; Plate 4) portrays the

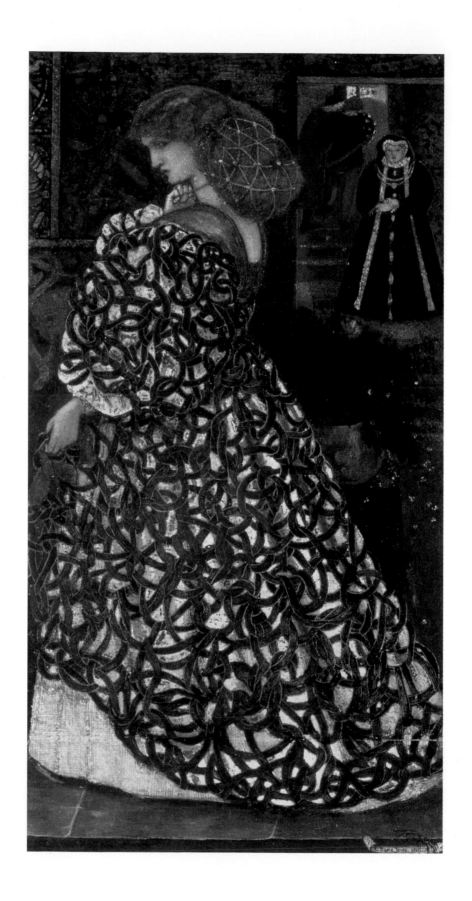

Sidonia von Bork

Plate 4, 1860. Gouache, 13 x 6¹¹⁄₁₆ in. (33 x 17 cm). Tate Gallery, London/Art Resource, N.Y.

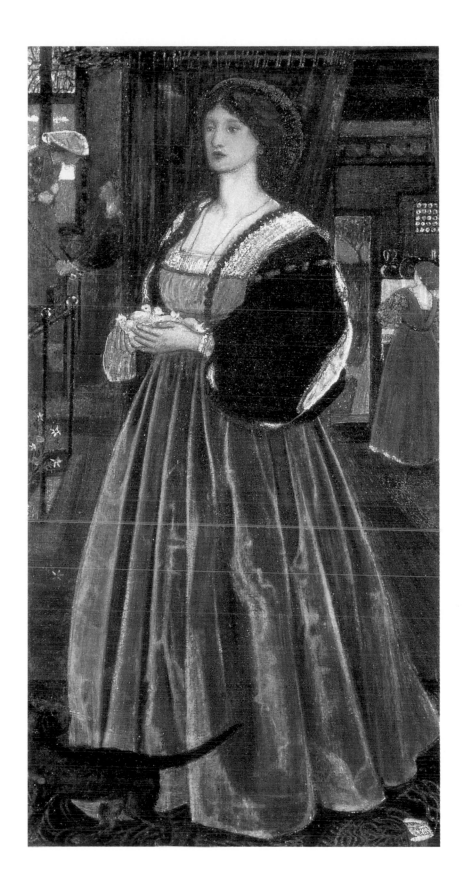

Clara von Bork

Plate 5, 1860. Gouache, 13⅜ x 7⅛ in. (34 x 18.1 cm). Tate Gallery London/Art Resource, N.Y.

eponymous temptress, whose dazzling beauty hid a vicious nature that brought down the ruling house of sixteenth-century Pomerania. Using the opulent ornamentation of her dress to suggest a web to trap her victims, Burne-Jones captures Sidonia in a moment of sinister self-absorption. The pendant image, *Clara von Bork* (1860; Plate 5), presents the virtuous wife of Sidonia's cousin Marcus. Modestly dressed, with a winsome demeanor, she is the stark opposite of the seductive sorceress. Burne-Jones based her appearance on that of his fiancée; her pale complexion, brown hair, and wide blue-gray eyes present an idealized reflection of Georgie. In her hands Clara cradles a nest of fledgling doves, an attribute of her gentle nature

Figure 11, Georgiana Macdonald at age sixteen. Black-and-white photograph by Walker E. Cockerell. From Georgiana Burne-Jones, *Memorials of Edward Burne-Jones* (London: 1904). By courtesy of the National Portrait Gallery, London.

and a tribute to the nurturing woman the artist chose as his life's companion.

The couple settled into rooms in Russell Place in London's Bloomsbury district. Their furnishings were sparse: a large simple table, high-backed chairs with rush seats, and a settle-style sofa of paneled wood—all designed by Philip Webb (1831–1915). As a wedding present, Burne-Jones's Aunt Katurah gave Georgie, who was an accomplished musician, a small piano. Burne-Jones decorated the panel

above the keyboard with an image of a woman dressed in a medieval gown, playing an organ while an allegorical figure of Love works the bellows. His own gift to his bride was a sideboard, which he embellished with figures of ladies and animals, illustrating the virtues of kindness and the sins of cruelty. The front room of the flat was reserved for Burne-Jones's studio. Georgie often read or sang to him as he worked.

Morris settled at Bexleyheath, Kent, ten miles south of London, in a home Webb designed for him (Figure 12). Set in an orchard of apple and cherry trees, the Red House was built of the warm-toned local brick. With its low-slung tiled roof and irregular silhouette, punctuated by spirelike chimneys and ogival arches, it bore the romantic air of a Gothic cottage. The spacious but unpretentious house became the regular weekend retreat for Burne-Jones and Morris's circle, which now included Webb, Rossetti and his wife, Charles Faulkner, the poet Algernon Charles Swinburne, and the painter Arthur Hughes. Conviviality reigned at Red House gatherings, and Burne-Jones captured the high spirits in affectionate caricatures of his host (Figure 13).

The Red House was also the site of active artistic col-

Figure 12, Red House at Bexleyheath, (built in 1859).
Black-and-white photograph by S. W. Newberry.
RCHME © Crown copyright.

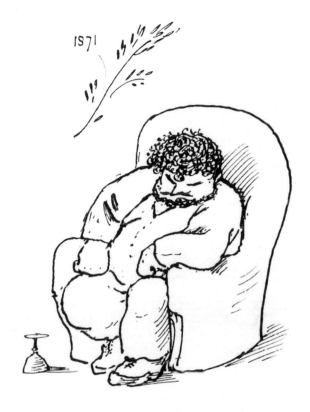

Home Again (Morris in an Armchair)

Figure 13, 1872. Pen and ink, 7 x 4½ in. (17.8 x 10.8 cm).
Courtesy of Sotheby's, London.

laboration. Morris recruited all of his friends to help decorate the interior. They designed household goods, stained-glass windows, tiles, and tapestries. They painted patterns on the ceilings and murals on the walls. Burne-Jones produced three scenes in tempera inspired by the fifteenth-century romance *The Marriage of Sir Degrevaunt*, with Morris and Jane as the models for the knight and his bride. In the decoration of the Red House, Burne-Jones and Morris gave a material reality to their romantic enchantment with the Middle Ages and strengthened their conviction that modern design could only improve through endeavors based in craftsmanship and camaraderie.

The decoration of the Red House led Morris to enlist his friends in a business venture. In April 1861, he formulated a prospectus for Morris, Marshall, Faulkner, and Company, Fine Art Workmen in Painting, Carving, Furniture, and the Metals. Rossetti later described the original idea as a lark: "One evening a lot of us were together, and we got to talking about the way in which artists did all kinds of things in olden times . . . and someone suggested—as a joke more than anything else—that we should each put down five pounds and form a company." In fact, the source for the start-up funds was an unsecured loan from Morris's family. Morris was elected manager, and he drew a salary, as did Faulkner, who kept the books. Each of the other founding members—Burne-Jones, Rossetti, Webb, Ford Madox Brown, and Peter Marshall, a professional surveyor who had an interest in industrial design—

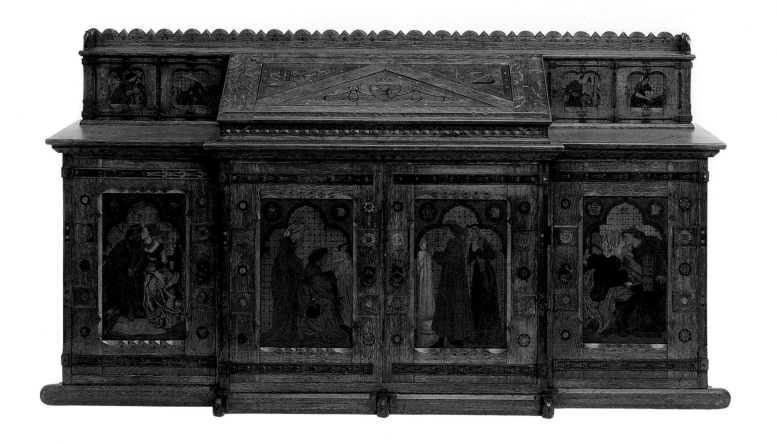

King René's Honeymoon Cabinet

Plate 6, EDWARD BURNE-JONES AND OTHERS, 1861–1862. Oak inlaid with various woods, painted metalwork, painted panels. Victoria and Albert Picture Library, London.

staked a small investment and agreed to participate on a cooperative basis for the promise of profit shares. The enterprise, which came to be known as the Firm, functioned as an artists' collective, with members contributing designs for individual projects. The actual fabrication of most of the goods was consigned to local craftsmen, who worked under Morris's supervision.

Recognizing the impracticality of trying fully to revive medieval cottage industry in the mid-nineteenth century, Morris sought to strike a balance among fine design, qual-

ity workmanship, and modern production. In forging a new unity between artist and craftsman, the Firm laid the groundwork for the influential Arts and Crafts movement, which rose first in Britain and then in America, enduring well into the twentieth century.

In 1862 the Firm submitted a selection of its decorative-arts designs to the International Exhibition at London's South Kensington Museum (now the Victoria and Albert Museum). Examples of painted furniture were installed in the exhibition's Medieval Court. One of the largest works,

the painted and inlaid *King René's Honeymoon Cabinet*, displayed the ease of collaboration among the core members of the Firm (1861–1862; Plate 6). The cabinet itself had been designed by the architect J. P. Seddon to hold building plans and drawings and was constructed at his father's woodworking firm. The decorative theme was based on imagined incidents in the life of the fifteenth-century French sovereign René of Anjou, who was renowned as a patron of the arts. The large decorative panels, depicting Architecture, Music, Painting, and Sculpture, were designed by Brown (who suggested the subject), Rossetti, and Burne-Jones, respectively. Valentine Prinsep painted a set of smaller panels, and Morris designed the decorative backgrounds. The cabinet drew mixed reviews but two of the Firm's other works won medals, and its stained glass was of such high quality that Morris was accused of touching up authentic medieval panels. The exhibition also led to sales of £150 and brought the Firm new clients for its interior designs.

Of all the artists working for the Firm, Burne-Jones emerged as the most versatile and the most prolific. He possessed an instinctive sense for decorative design, and his deeply ingrained sketching habit made him a fluid draftsman. Participation in a collaborative endeavor, particularly with his friends, gave him confidence and a sense of purpose. The subjects, selected from medieval legends and romances, from fairy tales and folklore, were the same that had engaged his mind since childhood. He took great satisfaction in the practical application of his designs. Like Morris, he strove to bridge the modern gulf between art and craft. But unlike his friend, he felt no need to ex-

periment directly with the techniques involved in production. He preferred to follow the example of the early Renaissance masters, from Giotto to Botticelli, who produced designs for skilled workers to transform into glass, tapestry, and mosaic.

Burne-Jones's decorative-arts designs often served as foundations for his paintings. For example, a set of tiles illustrating the fairy tale of Sleeping Beauty, commissioned in 1862 by the painter Miles Birket Foster for his new home, The Hill, in Surrey, marked the artist's first interpretation of a subject to which he would return in painting repeatedly during his career. Also, Morris's embellishment of a cabinet with the legend of St. George's adventures and marriage inspired a series of Burne-Jones paintings, likewise commissioned by Foster, in the 1870s. The challenge of design strengthened and simplified his aesthetic, stimulated his powers of invention, and enhanced the development of an elongated elegance in his figures and a tranquility in his composition. This is seen in the designs for a set of stained-glass panels, based on the tragic romance of Tristram and Isoude (Morris's spelling), made in 1862 for Harden Grange, the house of the merchant Walter Dunlap in Bradford, Yorkshire. Burne-Jones designed four of the twelve windows. (The others were done by Brown, Hughes, Morris, Prinsep, and Rossetti.) Even in a scene as charged with emotion as *The Attempted Suicide of La Belle Isoude* (Plate 7)—in which Tristram's star-crossed lover tries to end her life rather than live without him—Burne-Jones creates an atmosphere of grace and serenity.

During the early 1860s, John Ruskin took an active interest in shaping Burne-Jones's artistic growth. The promi-

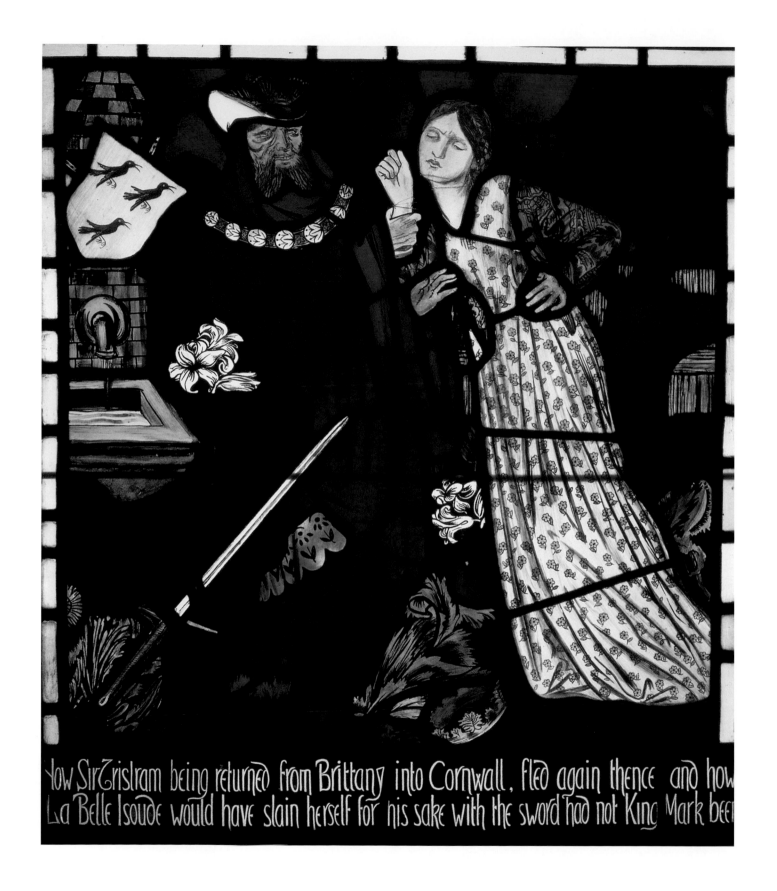

Jow Sir Tristram being returned from Brittany into Cornwall, fled again thence and how
La Belle Isoude would have slain herself for his sake with the sword had not King Mark been

The Attempted Suicide of La Belle Isoude

Plate 7, 1862. Stained-glass panel.Bradford Art Galleries and Museums/The Bridgeman Art Library International Ltd., London/New York.

nent, often contentious art critic had made a habit of selecting young artists and attempting to mold their futures through advice, encouragement, and patronage. The relationship he had cultivated with John Everett Millais came to an embarrassing end when his wife, Effie, fell in love with the young painter and, in 1854, demanded an annulment of their marriage. (Effie and Millais were wed shortly thereafter.) Ruskin then turned his attentions upon Rossetti and Elizabeth Siddal, generously giving Siddal an allowance and often paying for her rest cures and medical expenses. After Burne-Jones's extended stay at Little Holland House in the summer of 1858, Ruskin became friends with the budding artist and his fiancée, calling them "My dearest Children" and sharing with them his vast knowledge of art history as well as giving them access to his collections of books, drawings, and Old Master prints.

In 1860 Ruskin expressed dismay at Rossetti's continuing influence on Burne-Jones, complaining that the younger artist was "always doing things which need one to get into a state of Dantesque Visionariness before one can see them." Ruskin believed Burne-Jones needed more extensive exposure to the clarity and grandeur of early Renaissance art in order to break away from his imitative habits. Burne-Jones had, in fact, visited Italy, touring Florence and Venice with Faulkner and Prinsep in the autumn of 1859. But Ruskin felt that their unstructured sightseeing had not sufficiently enriched his work.

In May 1862, he took Burne-Jones and Georgie to Italy himself. Together they visited Parma and Milan, and the couple continued on their own to Verona, Padua, and Venice. Ruskin gave Burne-Jones lists of works to see and assignments to copy paintings, which he dutifully did, but with little pleasure, producing what he called "rotten little sketches." He was grateful for his self-appointed mentor's generous interest, and his introduction to the works of Carpaccio, Correggio, and Giorgione heightened his sensitivity to the lyrical effects of color. But, as on his earlier journey, viewing the great works of the Old Masters made him long to be back in his studio. Although Georgie recalled that seeing "the ancient pictures set him on fire," Burne-Jones lamented that his awe in their presence impeded his ability to pursue original work. "I should never paint another picture if I lived in Italy," he wrote. After a brief visit with Ruskin in Milan, the couple concluded their ten-week stay and returned to London.

Burne-Jones eagerly resumed his work for the Firm, but for several months, he floundered in his own studio. Georgie recorded that he "felt disposed to rail at himself unreasonably; saying that he took good subjects only to spoil them, and there was nothing so base and mean as for a man to take a good subject and spoil it." He began, then set aside, several works in watercolor; the fear of failing to attain the images he could see in his mind paralyzed his efforts. Throughout his career he suffered similar intervals of lost confidence. His wife observed that "misery" affected the progress of almost every fresh picture, causing him to either to abandon the work or to continue painting "without light or hope . . . when suddenly, even he could not say how, the change came, the cloud lifted and he knew where he was and what to do."

His emergence from this particular spell of daunted creativity came in the summer and early autumn months of

1863, when he completed several watercolors that reveal his advancing mastery and his deeper understanding of fifteenth-century art. *The Annunciation ("The Flower of God")* (1863; Plate 8) had its origin in a wood-engraving design commissioned by George and Edward Dalziel for their *Illustrated Bible* (1864). The elements of the composition—the angel Gabriel's appearance to Mary in an enclosed garden outside her window, the absence of the bedroom wall, the door opening to an inner room—all can be traced to Renaissance conventions for depicting the Annunciation. But in employing these elements, Burne-Jones replaced the claustrophobic atmosphere that linked his early work with Rossetti's aesthetic with open air and light. In addition, he subtly explored various shades of a single tone of red rather than engaging in harsh, jewel-bright contrasts as he had in earlier pictures. The motif of an angelic epiphany in a stream of light is an homage to one of his favorite paintings in the Accademia in Venice, Carpaccio's *Dream of St. Ursula* (1495). Many of the details—the raked perspective of the floorboards, the red draped bed, the shoes in the foreground, and the Turkish carpet—acknowledge another painting, Jan van Eyck's *Giovanni Arnolfini and His Wife* (1434). This work was in the National Gallery in London, and he knew it well.

Burne-Jones attained an even greater sense of synthesis in *The Merciful Knight* (1863; Plate 9). The subject is a miracle in the life of the Florentine saint John Gualberto: While out riding on Good Friday, he performed an act of mercy. Late in the day, as he knelt to pray at a roadside shrine, the wooden figure on the crucifix embraced him. Burne-Jones found this obscure tale in one of his favorite books from his Oxford years, Digby's *Broadstone of Honour*. The work has spatial affinities with *The Annunciation*; in fact, he was painting both pictures at the same time. The composition of *The Merciful Knight* also bears a clear resemblance to that of Rossetti's *Sir Galahad* (Figure 14), an illustration he produced for the edition of Tennyson's *Poems* published by Edward Moxon in 1857. But in its sense of depth and openness, with the golden light shining from the background, the painting is startlingly original, showing that Burne-Jones's vision was now fully his own. Georgie regarded the painting as pivotal in her husband's development. *"The Merciful Knight,"* she wrote, "seems to me to sum up and seal the ten years that had passed since Edward first went to Oxford." Just as Burne-Jones's 1858 image of Sir Galahad (see Figure 10) expresses his desire to pursue the elusive goal of a life in art, *The Merciful Knight* reflects his recognition that he was now passing from apprenticeship into maturity.

By 1864, the Red House circle began to disperse. The families had grown: Two daughters were born to the Morrises, and in October 1861 a son, Philip, was born to the Burne-Joneses. Tragedy afflicted Rossetti's life in 1862, with the stillborn birth of a child and the subsequent depression and suicide of his wife. Yet the Firm's business flourished, and in 1863 Morris proposed constructing several additions to Red House—outbuildings for craft studios and a new wing as a residence for the Burne-Jones family. Morris's attempt to bring the families closer together ended abruptly when Georgie, who was pregnant, contracted scarlet fever and delivered prematurely. The child, a boy, died within a few days. Burne-Jones named him Christopher,

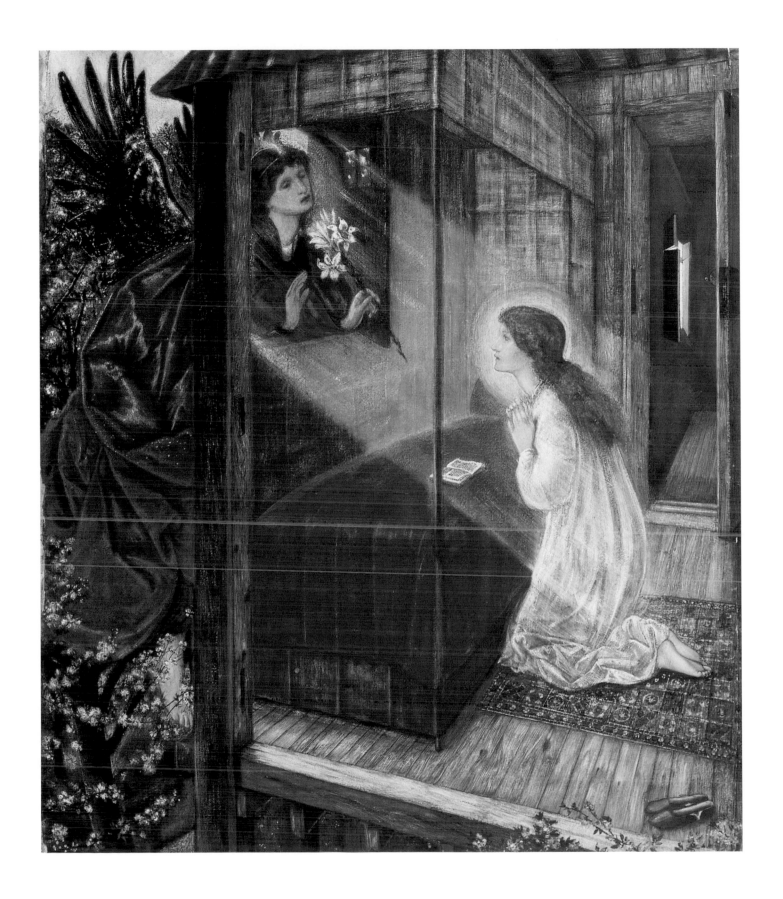

The Annunciation ("The Flower of God")

Plate 8, 1863. Watercolor and bodycolor, 23¾ x 20¾ in. (60.3 x 52.7 cm). Christie's Images.

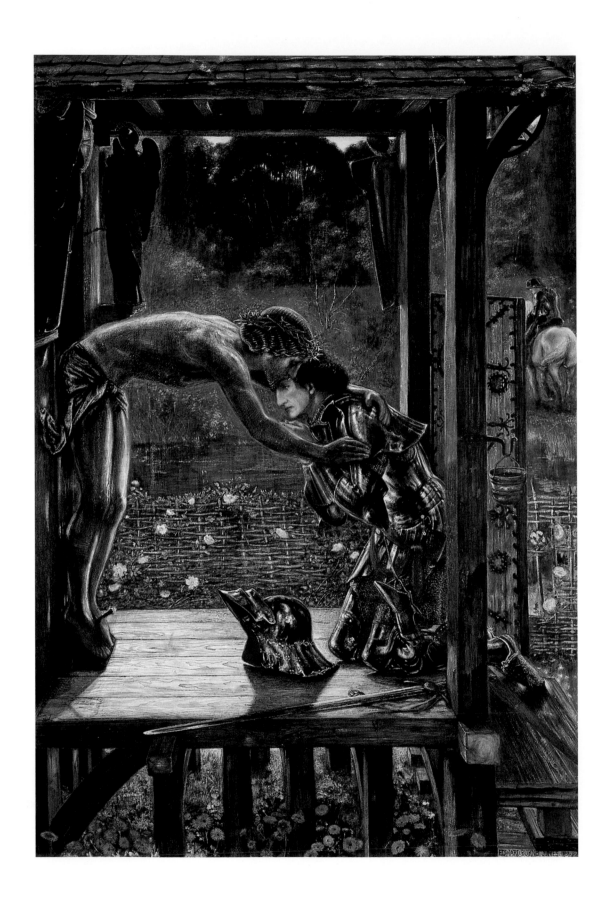

The Merciful Knight

Plate 9, 1863. Watercolor, bodycolor, and gum, 39½ x 27¼ in. (100.3 x 69.2 cm). Birmingham Museums and Art Gallery.

because "he had borne so heavy a weight as he crossed through the troubled waters of his short life." This crisis left Burne-Jones exhausted and burdened with medical bills, forcing him to withdraw from Morris's proposition. Morris, who was himself suffering from rheumatic fever, regretted that their shared dream of "our palace of Art" would not be realized. But, ever a realist and an optimist, he reminded his friend that they were still young and could look forward to "jolly years of invention." Within a year, however, Morris grew tired of commuting to London to conduct business and visit friends. He sold the Red House in 1865 and moved his family into a residence above a furniture-and-textiles showroom in Queen's Square.

Burne-Jones's painting *Green Summer* (1868; Plate 10) pays wistful tribute to the Red House years. The original version, done in watercolor in 1864, featured portraits of Jane Morris, Georgie, and Georgie's sister Louisa among the women relaxing on the grass in a cool lush glade, shaded from summer sun. The subtle play of nuanced color — variants of green tinged with gold or blue — defied prevailing notions of chromatic harmony and contrast. The

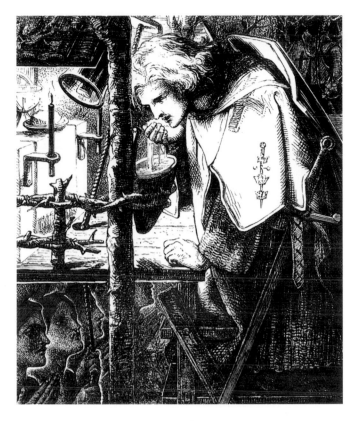

Sir Galahad

Figure 14, Dante Gabriel Rossetti (English, 1828–1882), illustration from Alfred Tennyson, *Poems* (London: 1857). Photo courtesy of The Newberry Library, Chicago

critic for the *Art Journal* dismissed the watercolor as nothing more than a "harmony in green." Burne-Jones repeated the work in oil four years later, generalizing the portrait identities but maintaining the poignant spirit. The women's languid postures, their self-containment, and their melancholic expressions give the image an air of an elegy, capturing the spirit of a time passed, never to return. The painting conveys this feeling not through narrative but through color, gesture, balance, and lyricism. Although elegiac in spirit, *Green Summer* reveals a new direction in Burne-Jones's art. Following the methods of the masters he admired in Venice — most notably Giorgione — Burne-Jones achieved a higher level of aesthetic expression. He now emphasized the purely visual experience of painting, giving his work a new depth of mood and mystery based on sensation rather than story. He would no longer be satisfied simply to pursue a life in art; he now sought to attain in his art a transcendent ideal of beauty. Silent, still, and timeless, his art offered a potential alternative to the experience of mundane reality, an idyllic existence that lay beyond his grasp but within his imagination.

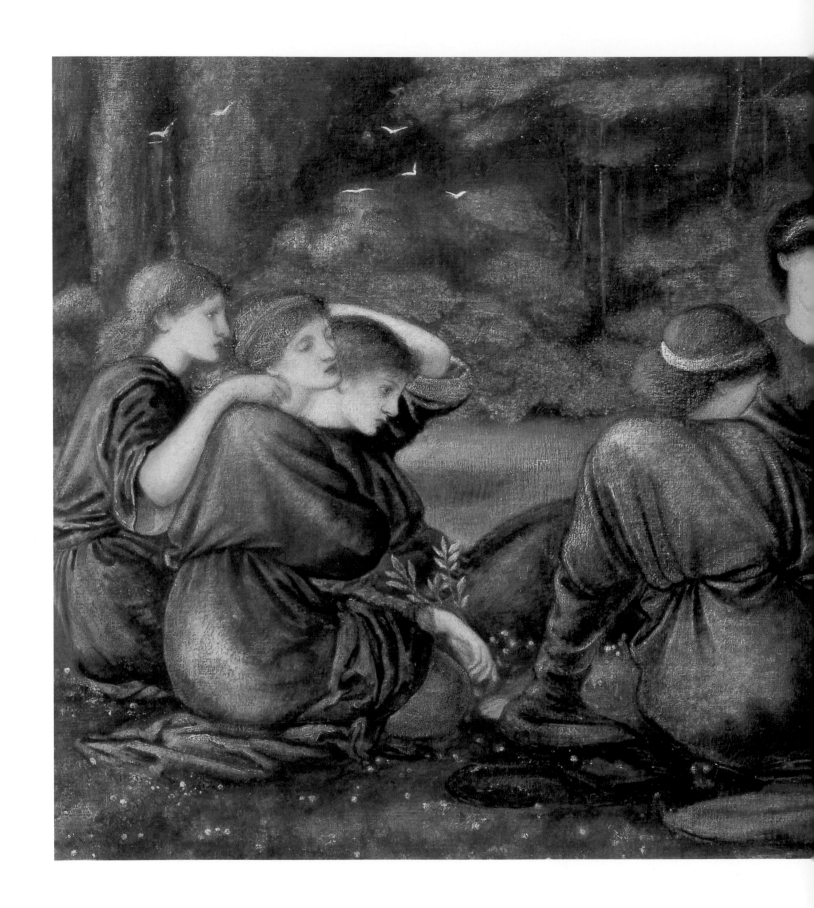

Green Summer

Plate 10, 1868. Oil on canvas, 25 x 41 in. (63.5 x 104.1 cm). Private collection. Courtesy Christie's Images.

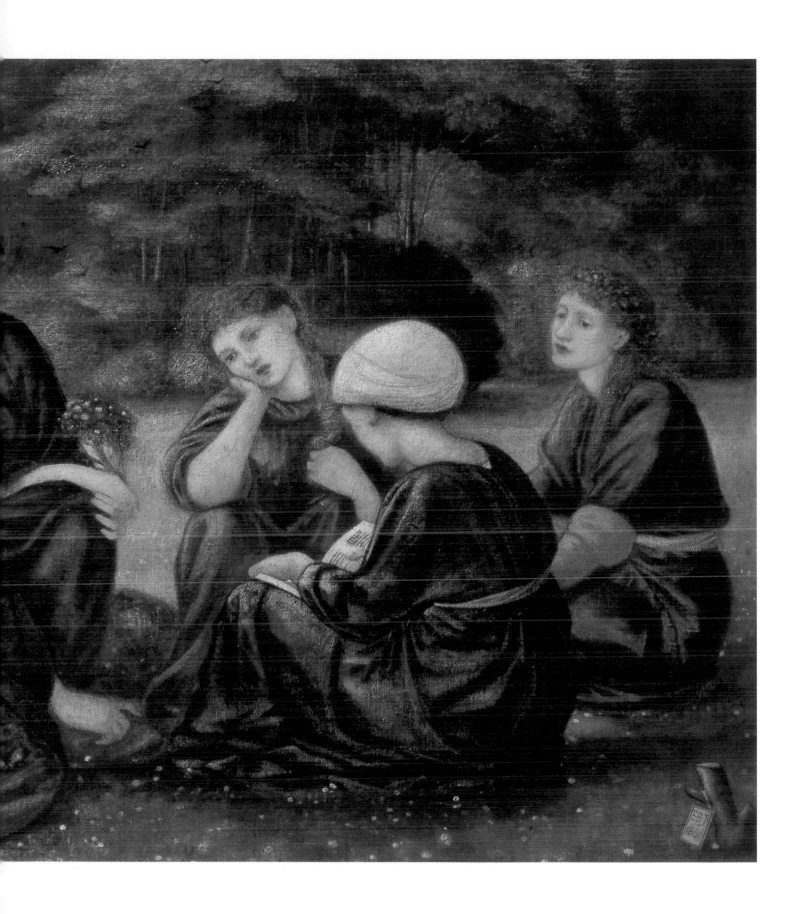

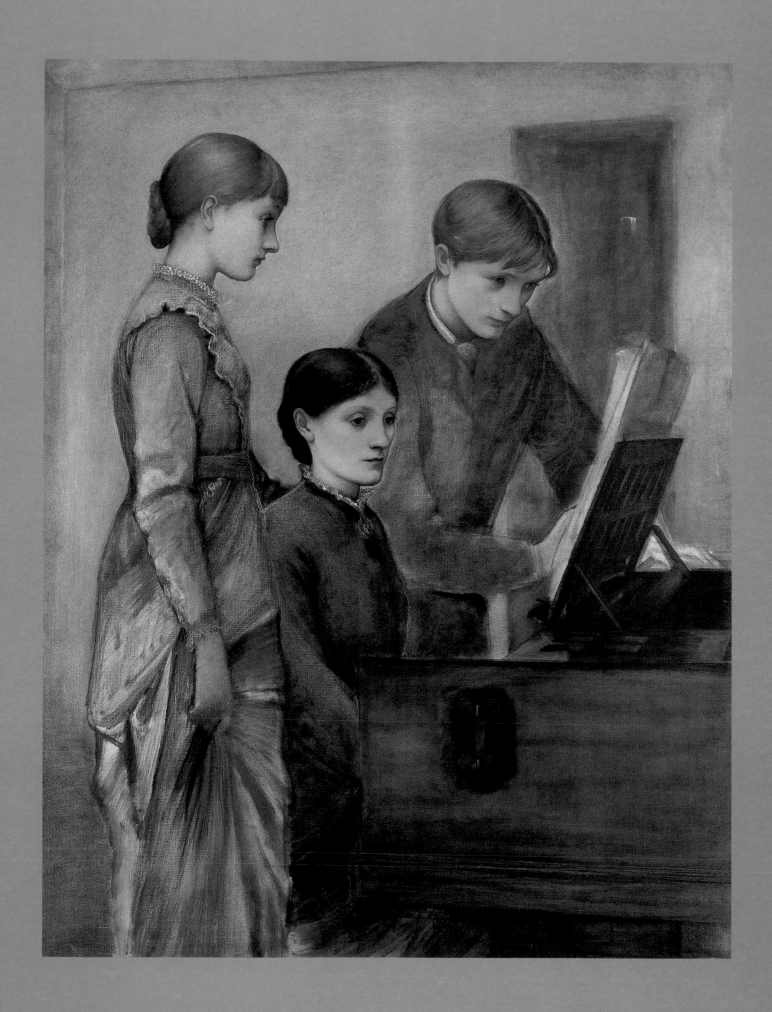

BEAUTY AND MISFORTUNE

Burne-Jones now entered a phase of emotional restlessness and artistic transition. To raise his professional profile, in 1863 he sought membership in the Old Water-Colour Society—an association of painters that staged yearly exhibitions—and was turned down. But on his second attempt, in 1864, he was elected an Associate. He submitted four paintings to the Society's spring exhibition, including *The Annunciation ("The Flower of God")* (see Plate 8) and *The Merciful Knight* (see Plate 9). This marked his public debut, and his unconventional work, displayed in a highly

conventional venue, struck the critics as peculiar. His "ultra manifestations of medievalism" baffled them. For example, the writer for the conservative *Art Journal* wondered: "What spectacles can he have put on to gain a vision so astounding. Had Duccio of Siena or Cimabue of Florence, walked into Pall Mall and hung upon these walls their mediaeval and archaic panels, surely no greater surprise could have been in reserve for visitors in the gallery." Burne-Jones also sensed hostility from his new colleagues, claiming that *The Merciful Knight* was hung too high for viewing; he interpreted this as evidence that they were "furious with me for sending it, and let me see that they were."

For the six years he was to maintain his membership in the Old Water Colour Society, Burne-Jones would endure mixed or negative

critical reception. But at the same time, he attracted new and generous patrons, such as William Graham, the Liberal member of Parliament for Glasgow, and Frederick Leyland, a wealthy Liverpool shipowner.

In 1865, to accommodate his growing business, he moved his studio and family to Kensington Square. He continued working for the Firm. To meet the increasing demands on his time, he hired studio assistants: Charles Fairfax Murray, in 1866; and Thomas M. Rooke, in 1869. His family grew as well. A daughter, Margaret, was born in 1866. A year later he purchased his first home, the Grange, on North End Lane in London.

Burne-Jones now widened his circle, striking up friendships, on the one hand, with such established practitioners of academic classicism as Frederic Leighton

(1830–1896) and Edward Poynter (1836–1919)—and, on the other, with Albert Moore (1841–1893) and James Abbott McNeill Whistler (1834–1903), both of whom adhered to the Aesthetic movement credo: "Art for art's sake." Yet, as Georgie observed: "Never in any sense did he become a man of the world, and up to a certain point it was always easy to take advantage of him: press that advantage too far, however, and he was gone like a bird from a snare."

A new project with Morris also broadened his vision. In 1865 Morris proposed that he design illustrations for a folio edition of a poetic epic he was writing, *The Earthly Paradise*. Inspired by the structure of Chaucer's *Canterbury Tales*, *The Earthly Paradise* revives the old traditions of storytelling. Morris's narrative premise brings together men of different times and cultures. A band of Norse mariners lose their way at sea. They land on an Aegean island where a classical society has survived the decline of the ancient world. The Norsemen remain on the island for one year, trading tales each month with their Greek hosts. *The Earthly Paradise* offers a cycle of twenty-four tales, twelve of them medieval in origin and twelve of them classical. Morris marked passages for illustration in his working manuscript, but he also read the work-in-progress to the Burne-

Morris Reading Poetry to Burne-Jones

Figure 15, c. 1865. Pencil, pen, and ink, 3⅝ x 4¹⁵⁄₁₆ in. (9.2 x 12.5 cm). Courtesy of Sotheby's, London.

Joneses so as to evoke the spirit of the oral tradition. On these occasions, Georgie recalled, she felt the need to bite her fingers or stick herself with pins, lulled into drowsiness by Morris's rhythmic chanting. Burne-Jones had a like reaction, caricaturing himself as falling asleep under Morris's hypnotic spell (Figure 15).

Burne-Jones began designing illustrations for the classical tales, producing seventy sketches for "Cupid and Psyche" (Figure 16), twenty for "The Hill of Venus," and twelve for "Pygmalion and the Image." Guided by woodcuts made for late-medieval incunabula, particularly a fifteenth-century volume of the *Hypnerotomachia Poliphili* that Morris owned, he drew images in bold, simple strokes with subtle shadows. Morris tried his hand at cutting the woodblocks, but most of the work was completed by George Wardle and other members of the Firm. The goal of a fully illustrated edition was never realized, for although Morris was pleased with the printed images, the pale impression made by the available typeface for the text failed to match their strength and clarity. When *The Earthly Paradise* was published, in three volumes by the Chiswick Press in 1868–1870, it bore a single Burne-Jones illustration—on the title page. Nonetheless, the project sparked a shared ambition in Burne-

Jones and Morris: to design and publish a beautiful book with text and images united as a pictorial expression.

His work on *The Earthly Paradise* led Burne-Jones to think in terms of a supra-mythology that merged legends of the classical and medieval worlds. This interpretative approach ran counter to prevailing practice. According to academic standards, classical subjects demanded strict adherence to conventions of form, sentiment, and high moral content, while medieval subjects, ungoverned by such rules, permitted a freer flight of imagination. Morris's mythic evocations in

The Earthly Paradise

Figure 16, proof pull of wood engraving for "Cupid and Psyche," for William Morris, c. 1870. 4 ½ x 3 in. (11.4 x 7.6 cm). Photo courtesy of The Newberry Library, Chicago.

and fragile beauty, they evoke the wistful nostalgia that he had previously portrayed as the spirit of the Middle Ages. Burne-Jones closed the chasm between the classical and medieval pasts; while Morris sought to present them as equivalent in poetry, Burne-Jones imagined a transcendent realm of myth in which the two disparate eras were the same.

During this time, Burne-Jones returned to the allegory of music and love he had painted above the keyboard of Georgie's piano when they were wed. In 1865 he reinterpreted the image in watercolor, adding a figure of a

The Earthly Paradise were unfettered by such constraints. Like Chaucer, he saw the ancient world through the nostalgic lens of medieval romance. And now Burne-Jones sought a similar vision in his art. He transformed his *Earthly Paradise* drawings into easel paintings such as *Cupid Delivering Psyche* (1867; Plate 12), in which the son of Venus rescues his lost love from captivity in Hades. Only the swirl of drapery and Cupid's fluttering wings distinguish the classical lovers from Burne-Jones's courtly knights and damsels. With their lithe grace, poignant expressions,

pensive knight and giving it the title *Le Chant d'Amour*. One year later, he painted the subject again in gouache, omitting the figure of Love. He began a third version, a large oil, in 1868 and worked intermittently on it for nine years (Plate 13). (Incremental labor on individual pieces over long periods was to be a routine practice throughout his career.) The original inspiration for the image was the words of a Breton ballad that reflected on the transitory nature of love: "Hélas! je sais un chant d'amour, Triste ou gai, tour à tour." (Alas! I know a song of love, sad or

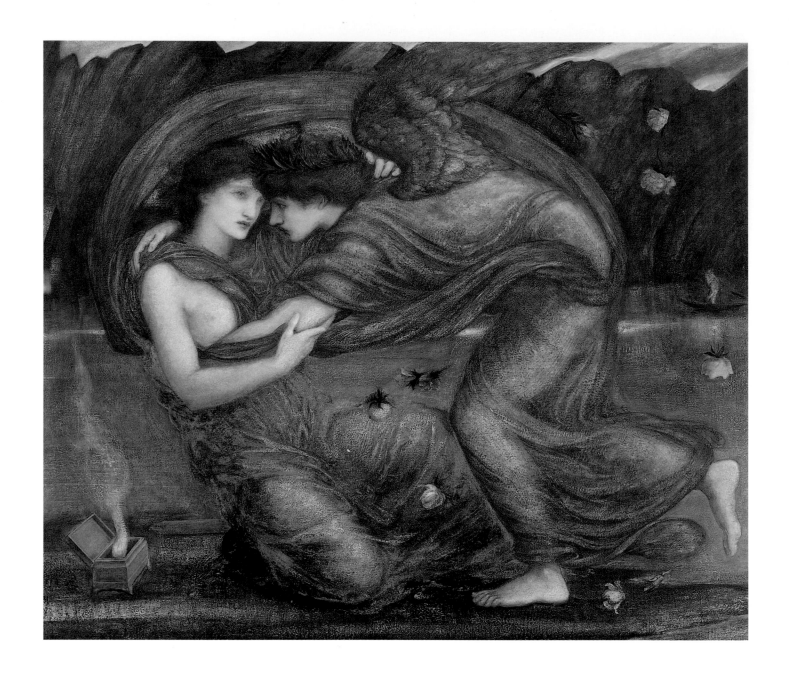

Cupid Delivering Psyche

Plate 12, 1867. Gouache, 31½ x 36 in. (80 x 91.4 cm). Hammersmith and Fulham Archives and Local History Centre.

happy, by turns.) In the final conception, Burne-Jones included three figures: the pensive knight listening to the romantic song, the elegant woman at the organ absorbed in her music, and the fragile figure of Love lost in reverie as he works the bellows. The glowing golden background

sets the scene at sunset and evokes an aura of melancholy. The warmth of the burnished palette, the synesthetic expression, and the unresolved narrative all recall Giorgione's allegory of poetry, *Fête Champêtre* (c. 1510; painted with Titian), which Burne-Jones had seen in

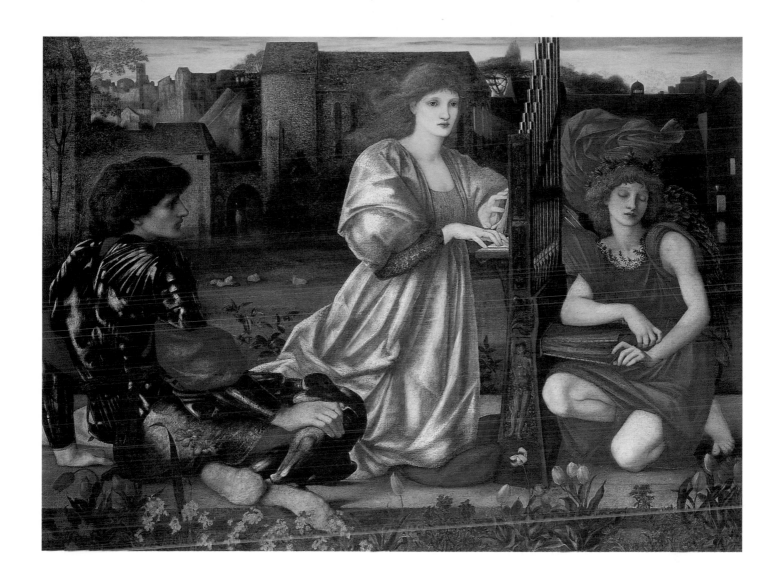

Le Chant d'Amour

Plate 13, 1868–1877. Oil on canvas, 45 x 61⅜ in. (114.3 x 155.9 cm). The Metropolitan Museum of Art, the Alfred N. Punnett Endowment Fund, 1947. Photograph © The Metropolitan Museum of Art.

the Louvre. But the pervasive sense of yearning in *Le Chant d'Amour,* expressed in the faces of the figures, their furtive gazes, and the self-containment that divides them, gives the intellectual appeal of the allegory an intimate connection with the emotions. Georgie once observed that "beauty and misfortune" held her husband in their sway, "and far would he go to serve either." *Le Chant d'Amour* allies the two as one; its poignant

message tempers pleasure with pain, recognizing the pang of unfulfillment that is the source of all desire.

By the end of the decade, Burne-Jones would know at first hand the torment of longing and loss expressed in *Le Chant d'Amour.* In 1866 Euphrosyne Cassavetti had visited his studio with her daughter, Mary Zambaco, and her niece, Marie Spartali. Cassavetti was a member of the cosmopolitan Ionides family, leaders of the Greek cultural

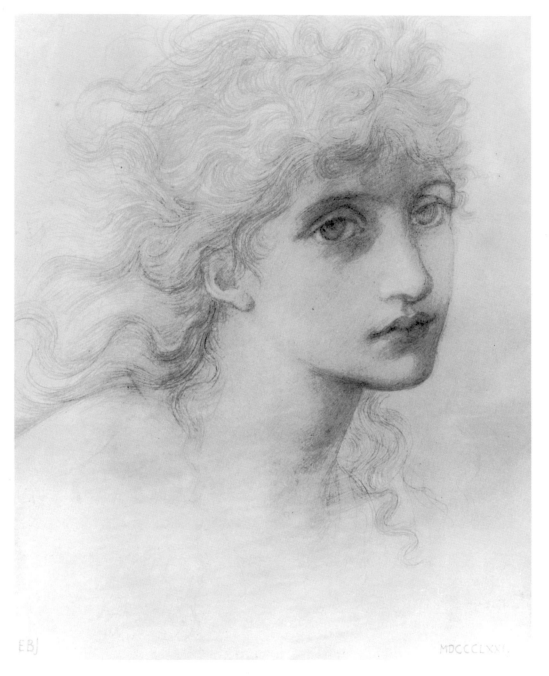

EBJ MDCCCLXXI

Drawing of Mary Zambaco

Figure 17, 1871. Pencil, 10½ x 8½ in.(26.7 x 21.6 cm). Courtesy of Sotheby's, London.

expert on venereal disease from Constantinople. The marriage ended when she deserted her husband and two children in Paris to return to her mother's home. Like Spartali, she possessed a striking beauty, but she was small in stature, with strong, exotic features. Another cousin, Luke Ionides, wrote of her "glorious red hair and almost phosphorescent white skin." Cassavetti asked Burne-Jones to paint portraits of the two women. Disinclined to render simple likenesses, he had them sit for the figures in one of his Earthly Paradise paintings, *Cupid Finding Psyche* (1867–1887). Pleased with the result, Cassavetti purchased the work and continued to commission works from Burne-Jones.

Zambaco made herself a constant presence in Burne-Jones's studio, and soon he became infatuated. While rumors rather than documents testify to the nature of their relationship, the pervasive appearance of this distinctively beautiful woman in Burne-Jones's art of the late 1860s demonstrates his passionate ob-

community in London and generous patrons of the arts. Spartali was an aspiring painter. Tall and classically beautiful, she modeled on occasion for Rossetti. Zambaco was a sculptor. Five years earlier, against the wishes of her family, she had married Dr. Demetrius Zambaco, a renowned

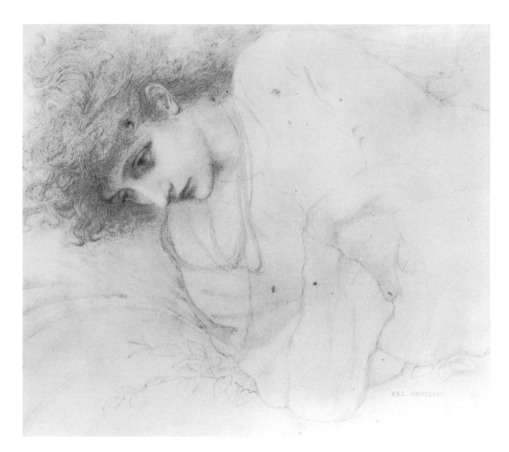

Drawing of Mary Zambaco

Figure 18, 1871 Pencil, 13 x 14½ in. (33 x 36.8 cm). Courtesy of Sotheby's, London.

session with her clearly enough. For several years, the artist's friends abstained from comment on his behavior, and Georgie, the very model of Victorian decorum, carried on her duties as wife and mother as if nothing had changed.

But by January 1869, the relationship could no longer be ignored. That month, Rossetti wrote to their mutual friend the painter Ford Madox Brown that Zambaco had caused a scandal, threatening suicide in public and brandishing a vial containing enough laudanum "for two at least." She then attempted to drown herself in the Regent's Canal; in Burne-Jones's attempt to stop her, Rossetti wrote, he wrestled her to the ground. Local residents called the police. Her outburst, it seems, was triggered when Burne-Jones changed his mind about leaving his family to join her in Greece. Rossetti's natural tendency to exaggerate notwithstanding, the incident was so sensational—and so mortifying—that Burne-Jones now sought to avoid Zambaco. It was at this point that his friends intervened. Morris tried to take him to Italy, but Burne-Jones collapsed in exhaustion by the time they got to Dover.

Throughout their marital crisis, Georgie kept mute. Even in her biography of her husband, she referred to that time—avoiding mention of the disruption of her household—as "a second life [when] we finally put away childish things and had our share of sorrow." Only after the crisis

had passed was she willing to admit that something had gone wrong. Writing in February to her friend Rosalind Howard, she expressed her tentative hopes: "May we all come well through it at last. I know one thing and that is that there is enough love between Edward and me to last out a long life if it is given to us."

The question of why Burne-Jones entered into a liaison that jeopardized his marriage, his personal reputation, and, potentially, his career still stirs much speculation. His use of Zambaco's and Georgie's likenesses in a series of allegorical paintings begun in 1869 may offer insight. In 1868 he had written to his patron Frederick Leyland proposing a set of panels—depicting day, night, and the four seasons—to be installed in the dining room of Leyland's new home on Prince's Gate in London. Morris composed a set of quatrains that were to be inscribed beneath each allegory (Plates 14–17). Burne-Jones's work on the panels *Summer* and *Winter* was done in the wake of his romantic debacle. The figure of *Summer*—with her sorrowful eyes, aquiline nose, and luminous skin—bears an unmistakable resemblance to Mary Zambaco. Standing

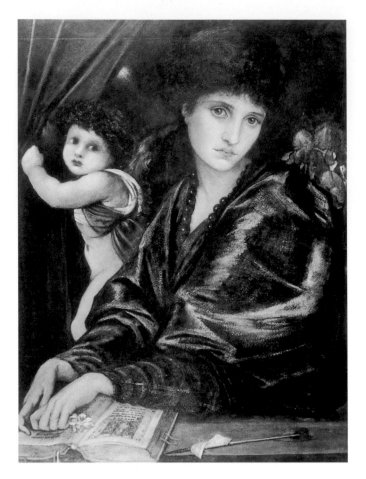

Portrait of Mary Zambaco

Figure 19, 1870. Gouache heightened with bodycolor, 31 x 22 in. (78.7 x 55.9 cm). Clemens-Sels Museum, Neuss, Courtesy of Sotheby's, London.

at the edge of a shimmering pond, she unties the shoulder of her diaphanous gown, which hides little of her supple form. There is a thicket of apple trees behind her, and forget-me-nots grow at her feet. She invites sensual pleasure, but, like the season she represents, her favors are fleeting. Morris's accompanying lines bear this out: "Summer looked for am I/ Much shall change or ere I die;/Prythee take it not amiss/Tho' I weary thee with bliss." *Winter,* by contrast, is swathed in a fur-lined gown and is lost in her reading. She warms her left hand over the fire that burns in a marble hearth, and her words speak not of what passes but of what endures. "I am winter, that doth keep/Longing safe amidst of sleep," reads Morris's text. With her wide, blue-gray eyes and aura of serenity tinged with melancholy, the figure of *Winter* is an idealized likeness of Georgie.

A series of sensitive drawings of Zambaco's face, many signed by the artist with the dates 1870 and 1871, suggest that Burne-Jones may have continued seeing her in his studio (Figures 17 and 18). The close observation displayed in these sketches indicates that his passion—and his ob-

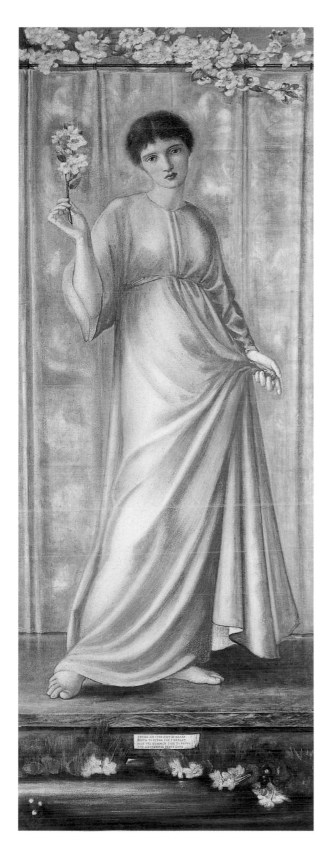

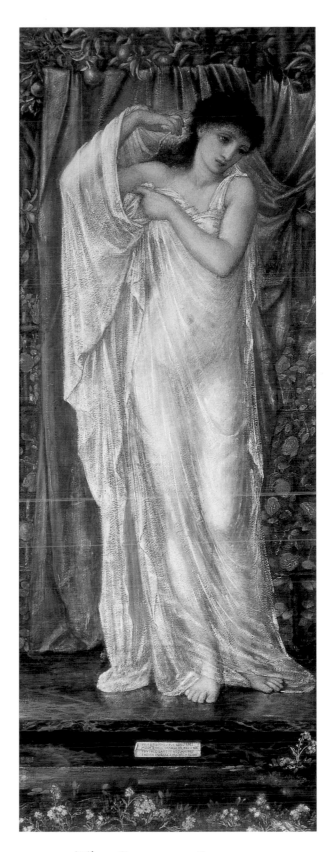

The Seasons: Spring

Plate 14, 1869. Gouache, 48¼ x 17¹¹⁄₁₆ in. (122.6 x 44.9 cm). Roy Miles Gallery, London/The Bridgeman Art Library International Ltd., London/New York.

The Seasons: Summer

Plate 15, 1869. Gouache, 48¼ x 17¹¹⁄₁₆ in. (122.6 x 44.9 cm). Roy Miles Gallery, London/The Bridgeman Art Library International Ltd., London/New York.

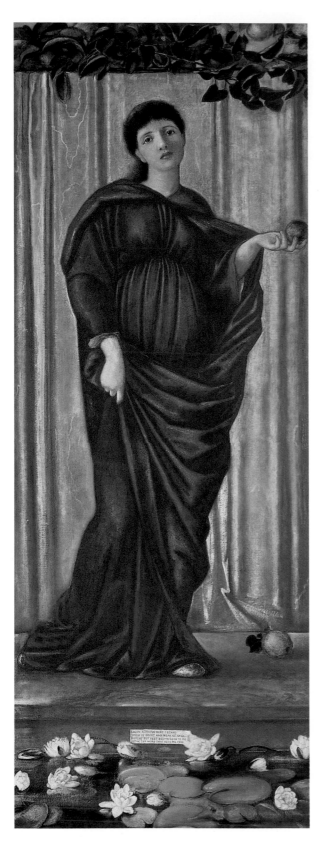

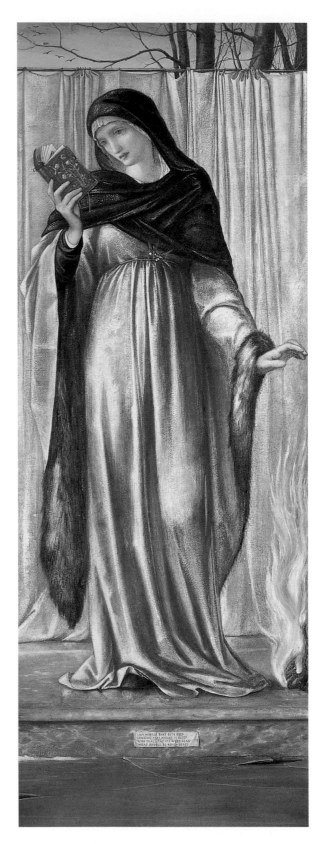

The Seasons: Autumn

Plate 16, 1869. Gouache, 48¼ x 17¹¹⁄₁₆ in. (122.6 x
44.9 cm). Roy Miles Gallery, London/The Bridgeman
Art Library International Ltd., London/New York.

The Seasons: Winter

Plate 17, 1869. Gouache, 48¼ x 17¹¹⁄₁₆ in. (122.6 x
44.9 cm). Roy Miles Gallery, London/The Bridgeman
Art Library International Ltd., London/New York.

session—had not yet waned. These works are variations on a single theme. The mournful cast of her features, the general malaise reflected in her expressions, and the yearning depth of her gaze all mark the torment of unfulfilled desire. He also painted her portrait in 1870 as a present for her mother in honor of her daughter's birthday (Figure 19). Her eyes, as in the drawings, are imploring, but the wealth of attributes here articulate the painter's state of mind rather than the sitter's feelings. Behind her, a sorrowful Cupid draws back a curtain as if to reveal the source of love. A slip of paper wrapped around his arrow reads, "Mary Aetat XXVI August 7th 1870 EBJ pinxit." The blooming iris heralds a message, while the tattered rose in her hand testifies to the anguish of passion. Her hands rest on an open illuminated manuscript, with a miniature rendering of *Le Chant d'Amour.*

About thirteen years later, Burne-Jones painted a portrait of Georgie that bears an uncanny compositional resemblance to the Zambaco portrait (Figure 20). As in the earlier work, the sitter is positioned as if in a fifteenth-century Flemish portrait, seen from the waist up, leaning on

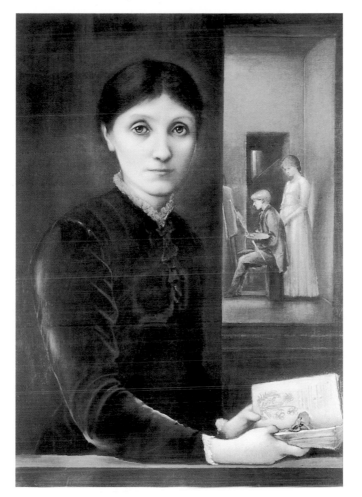

Portrait of Georgiana Burne-Jones

Figure 20, c. 1883. Oil on canvas, 30¹⁵⁄₁₆ x 21 in.
(78.6 x 53.3 cm). Paul Mellon Centre
for Studies in British Art.

a ledge. But behind Georgie, instead of Cupid, are the couple's children. They enact their parents' relationship: Philip paints at an easel while Margaret watches quietly behind him. Like Zambaco, Georgie holds a book and a flower. The book is an illustrated botanical, suggesting the patience and care demanded of a good gardener. The flower is a hearts ease pansy. In the language of flowers, the pansy declares, "You occupy my thoughts." Zambaco had brought beauty and misfortune to his life; Georgie gave him support and security. Burne-Jones had made his choice.

In the spring of 1870, the Old Water-Colour Society requested that Burne-Jones remove his large gouache *Phyllis and Demophoön* (1870; Plate 18), which featured a nude and a partially draped figure, from that season's exhibition. The president of the Society, Frederick Tayler, claimed he had received a letter of complaint from an offended viewer. Burne-Jones sent a polite letter, agreeing with the request. But when the Society next asked that he help select a work by another artist to replace *Phyllis and Demophoön,* he refused to comply. When the

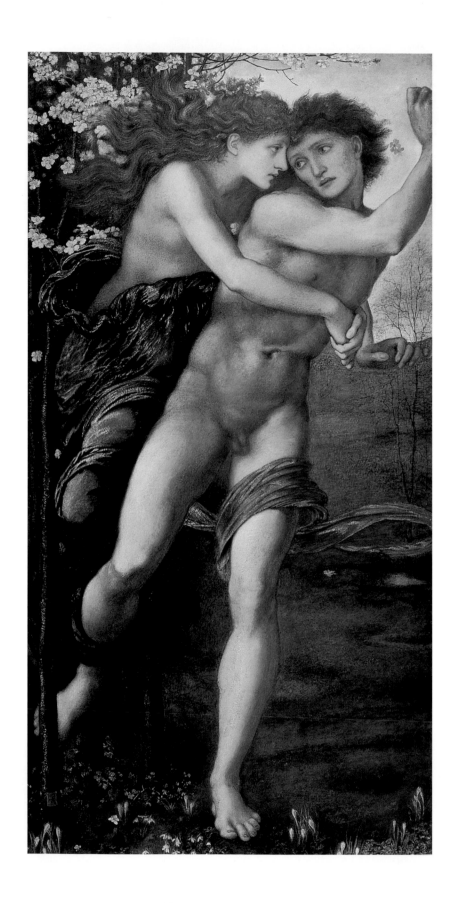

Phyllis and Demophoön

Plate 18, 1870. Watercolor and bodycolor, 36 x 18 in. (91.4 x 45.7 cm). Birmingham Museums and Art Gallery.

exhibition closed at the end of July, he resigned his membership. In a letter to the Society he asserted that

> *The conviction that my work is antagonistic to yours has grown in my mind for some years past and cannot have been felt only on my side—therefore I accept your desertion of me this year merely as the result of so complete a want of sympathy between us in matters of Art, that it is useless for my name to be enrolled amongst yours any longer.*

The Society asked him to reconsider his decision, but he did not.

It is unlikely that the simple matter of nudity in *Phyllis and Demophoön* prompted the Old Water-Colour Society to have the picture withdrawn. Nude figures had of course long been deemed appropriate in depictions of classical subjects. Moreover, the source from which Burne-Jones drew was a venerated one, the Roman poet Ovid's *Heroides*. (The story was recast in Chaucer's long poem *Legend of Good Women.*) In the story, Phyllis, the Queen of Thrace, falls deeply in love with Theseus's son Demophoön when he stops at her court on the way home to Athens after the Trojan War. On leaving, he pledges to return within the month. But he does not come back as promised, and Phyllis is plunged into grief. Athena takes pity on her and transforms her into an almond tree. Eventually, Demophoön does return, hears of Phyllis's fate, and runs to embrace the tree. Long barren, the tree bursts into bloom.

In his painting, Burne-Jones depicts Phyllis as emerging from the tree and embracing her lover, who struggles in her grasp. The critic for the *Times* of London found this choice offensive, especially "the idea of a love chase, with a woman follower." The image of Phyllis bore a clear resemblance to Zambaco, and Burne-Jones's decision to append Phyllis's lament—"Tell me what I have done, except to love unwisely"—to the painting led London art world gossips to regard the work as a confession. But other features of the painting branded it as objectionable. By draping Phyllis and exposing Demophoön, Burne-Jones reversed the acceptable gender roles in works portraying nudes. Even more, the sinewy grace of the figures was disturbingly dynamic, physical, and sensual—a flagrant departure from the dictated classical canon, which was rooted in antique sculpture. In his imaginative interpretation, Burne-Jones seemed to mock convention; that, more than anything, was bound to offend.

In severing his ties with the Old Water-Colour Society, Burne-Jones felt he had reclaimed his artistic freedom. The distrust for exhibiting institutions that Rossetti had instilled in him had now grown quite strong: He would shun public exhibition for the next seven years. He later called this time "the seven blissfullest years of work that I ever had; no fuss, no publicity, no teasing about exhibiting, no getting pictures done against time." Working away from the uncomprehending eyes of the art world and the unsympathetic words of the critics, Burne-Jones shielded himself from intrusive scrutiny and unwanted opinions. Safe in the confines of his studio, with only his imagination to guide him, he entered a phase of new confidence and command.

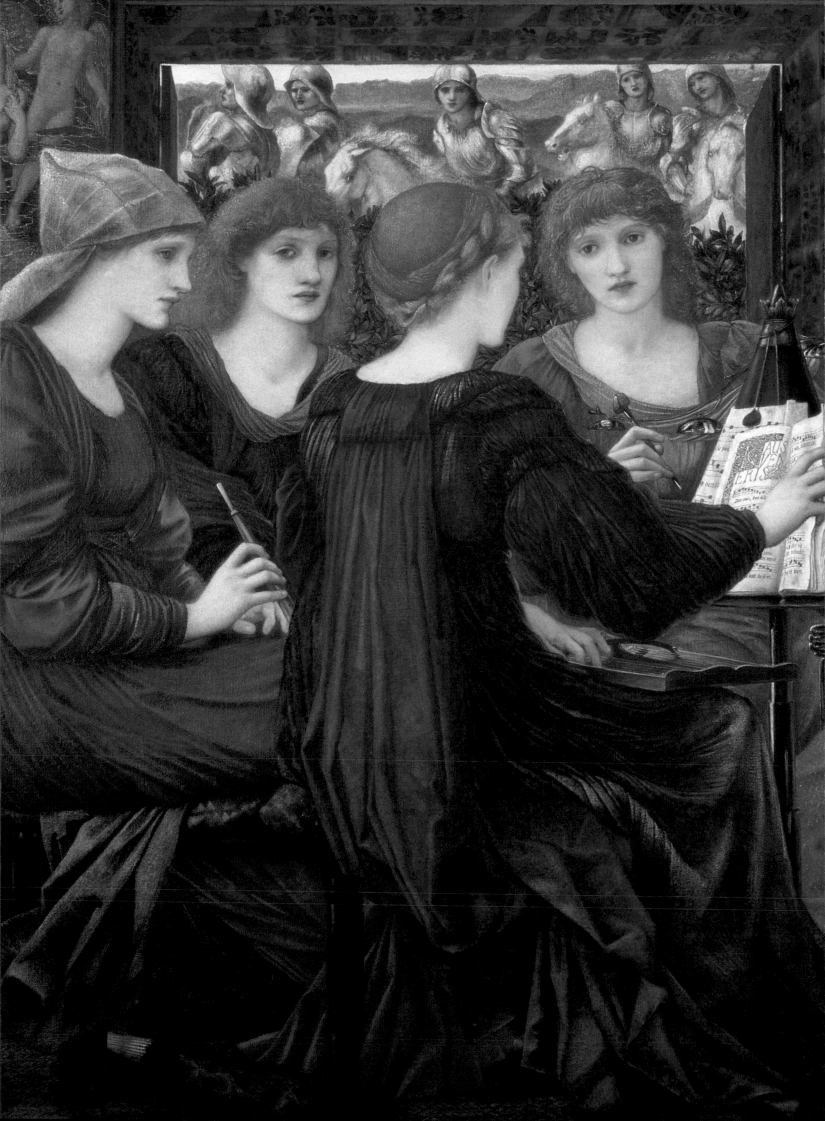

From That Day He Belonged to the World

A haunting portrait, painted by George Frederick Watts in 1870, gave the London art world an enigmatic glimpse of Burne-Jones at the precise moment he withdrew from its scrutiny (Figure 21). Like a ghostly apparition, the long pale face—framed by wispy tendrils of hair and beard—emerges from the background gloom; this is more the gaunt visage of a medieval mystic than the face of a modern painter. The eyes are wide but wary, the mouth has a nervous fragility, and the sitter is reticent under the viewer's gaze. Watts painted the likeness as a gift for Georgie, who agreed to

lend it to the Royal Academy for its summer exhibition that year. With great sensitivity, Watts captured the ethereal spirit of his friend. But for the contemporary audience, the work served only to confirm popular assumptions about the artist. As peculiar and remote as his paintings, Burne-Jones seemed to fade from view.

For seven years, he guarded his professional privacy and avoided public display of his work. Commissions from sympathetic patrons—who, besides William Graham and Frederick Leyland, now included the Conservative politician Arthur Balfour—and design work for the Firm provided the income he needed. Free from exhibition deadlines, Burne-Jones indulged his preferred practice in the studio, starting a number of projects and working on them as whim dictated. If difficulties arose with one painting, he simply took up another. Although his method was slow and deliberate, often stretching the time invested in a single work over many years, his industry was enormous. In his studio record for 1871, for instance, Burne-Jones listed more than twenty-seven works-in-progress, many of which involved multiple designs.

During this time, guests entered his studio only in his presence. In February 1873, he made a singular exception to his self-imposed refusal to exhibit by sending two paintings, *Love among the Ruins* (1872) and *The Hesperides* (1872), to the Dudley Gallery. They received little critical notice, but admirers appreciated the opportunity to see the new images. "I want in grati-

Portrait of Edward Burne-Jones

Figure 21, GEORGE FREDERICK WATTS (English, 1817–1904), 1870. Oil on canvas, 25½ x 20½ in. (64.8 x 52.1 cm). Birmingham Museums and Art Gallery.

come to her notice with his striking work *Phyllis and Demophoön* (see Plate 18) in 1870, but she heard nothing about him after that and "thought the painter must be dead."

Although Burne-Jones stayed out of the public eye, he did not keep himself secluded in his studio. He made two trips to Italy, alone in the autumn of 1871 and with Morris in the spring of 1873. The art that now interested him marked a distinct shift in his taste. He sought out "Giotto at Santa Croce, and Botticelli everywhere, and Orcagna in the Inferno at Santa Maria Novella, and Luca Signorelli at Orvieto, and Michelangelo always." While his reverence for Trecento painting had not flagged, his enthusiasm for the masters of physi-

tude to tell you that your work makes life larger and more beautiful to me," the novelist George Eliot wrote him in 1873. Typically, though, he was a forgotten figure. As one woman confessed to Georgie years later, Burne-Jones had

cal beauty and intensity—Botticelli, Michelangelo, and Signorelli—led to disputes with John Ruskin, who lamented this new influence. Although the critic remained close to Burne-Jones and his family and continued to

praise the artist's work, their bond as mentor and protégé was clearly broken.

There were other changes in Burne-Jones's circle of friends. In June 1872, Rossetti suffered a severe mental and physical breakdown. He never fully recovered either his health or his spirit, living his last ten years engulfed in sorrow and inertia. Burne-Jones dutifully wrote and visited him, but their relationship was never the same as it had been. Morris, like Burne-Jones, was following new directions in his work. In 1871 he moved his family out of London to Kelmscott Manor, an old house he purchased in Oxfordshire. The same year, he made his first trip to Iceland. Upon his return, he became deeply involved in translating the *Volsunga Saga*, the late-thirteenth-century compilation of tales about the Icelandic hero Sigurd and his ancestors. Morris worked for several years with the scholar Erikur Magnusson to produce *The Story of Sigurd the Volsung* (1876), the first version of this epic to appear in English prose. The old friends now had distinctly different interests, but their bond was strong, and, despite the geographic distance between their homes, their families remained close.

In 1875 Morris, Marshall, Faulkner, and Company was dissolved. Morris reorganized the Firm under his own direction as Morris and Company. Several members of the original firm protested the small profits they received at the end. This led to strained relations with Morris, particularly on the part of Ford Madox Brown (who also broke with Burne-Jones) and Rossetti. Burne-Jones provided designs for the new firm, which was run more conventionally. Despite this, he often had difficulty

Figure 22, Burne-Jones at Naworth Castle, 1874. Black-and-white photograph by B. Scott and Son. Courtesy of the National Portrait Gallery, London.

extracting his fees from Morris. In one instance when the "price was not originally fixed," his request for payment incited a lecture from Morris on "a shifting principle termed honour—this combined with sudden outbursts of social views on the subject of property." Burne-Jones accepted such tirades with affection. Even Morris's burgeoning socialist views—with which his friend did not agree—could not shake the deep love and respect they held for one another.

New friends and colleagues enhanced the Burne-Joneses' social and intellectual life. Through Georgie, he became well acquainted with George Eliot and her

companion, George Henry Lewes. He also forged a closer friendship with George Howard (later, the Earl of Carlisle), a talented amateur painter whom he had met at Little Holland House in the summer of 1858. In addition, his bond with Watts strengthened; they shared a desire to create "symbolical" paintings as well as a disdain for contemporary reviewers and their conventional standards. But Burne-Jones did not limit his friendships to people with whom he agreed. In those same years, for example, one of his valued associations was with Frederic Leighton, perhaps the most successful member of the conservative Royal Academy.

Now confident and intensely focused, Burne-Jones transformed his aims in art. He confessed a desire to paint on a large scale: "I want big things to do and vast spaces, and for common people to see them and say Oh!—only Oh!" At the same time, however, he acknowledged that the "chance of doing public work rarely comes to me." Nonetheless, he formulated a new approach that fulfilled his expanding vision, conceiving of works in cycles: series of related paintings to be installed together as an unfolding invention on a given theme. Freedom from exhibition deadlines also enabled him to pursue perfection single-mindedly, and he often returned to earlier subjects and compositions in order to improve upon what he already accomplished. Striving

Figure 23, The Burne-Jones and Morris families, 1874. Black-and-white photograph by F. Hollyer. Courtesy of the National Portrait Gallery, London.

to approximate the powerful physicality exhibited in the works that had so moved him on his visits to Italy, he drew relentlessly from life models, filling sketchbooks with studies of the nude. Only his subjects remained the same: Myth and legend still shaped his dreams, but he sought grander forms through which to express them.

His set of paintings depicting the Greek myth of Pygmalion, produced between 1875 and 1878, reveals this synthesis. Using the Roman poet Ovid's *Metamorphoses* as his source, Burne-Jones first illustrated the tale of the sculptor king of Cyprus who falls in love with his ivory statue representing his ideal of womanhood for Morris's *The Earthly Paradise.* During 1868–1870, he repeated the subject in a quartet of small oil paintings for Mary Zambaco's mother, Euphrosyne Cassavetti. Within five years he returned to the series; he painted the images half again as large and had them installed in monumental, inscribed frames. Burne-Jones did not change the basic composition, however, or the narrative structure: *The Heart Desires* (Plate 19) presents a pensive Pygmalion in his studio; *The Hand Refrains* (Plate 20) reveals Pygmalion contemplating the beauty of his creation; *The Godhead Fires* (Plate 21) depicts Venus transforming the marble into flesh; and *The Soul Attains* (Plate 22) shows Pygmalion dropping to his knees and grasping the hands of Galatea,

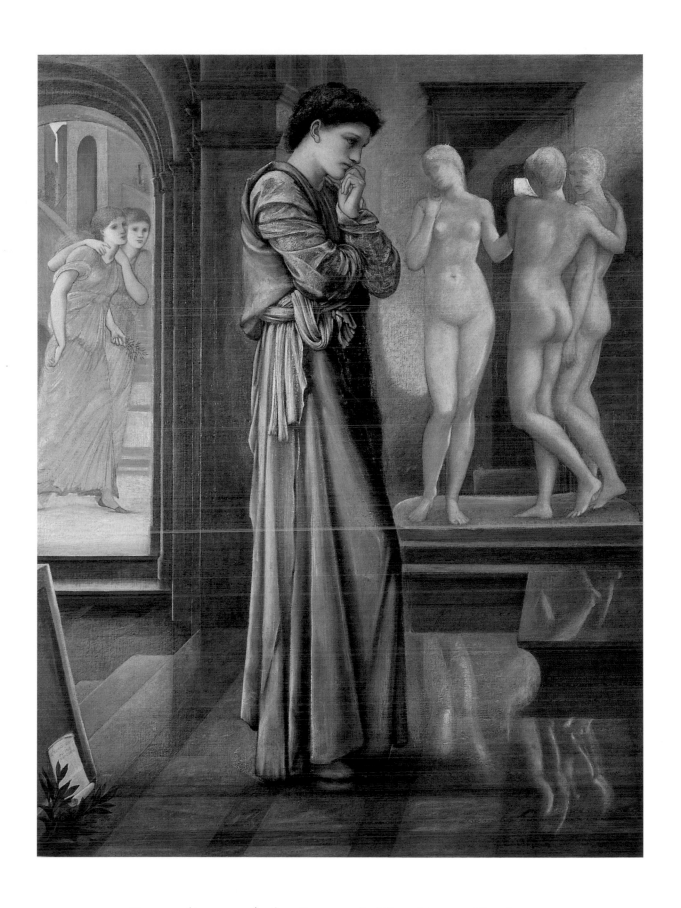

Pygmalion and the Image I: The Heart Desires

Plate 19, 1875–1878. Oil on canvas, 39 x 30 in. (99.1 x 76.2 cm). Birmingham Museums and Art Gallery.

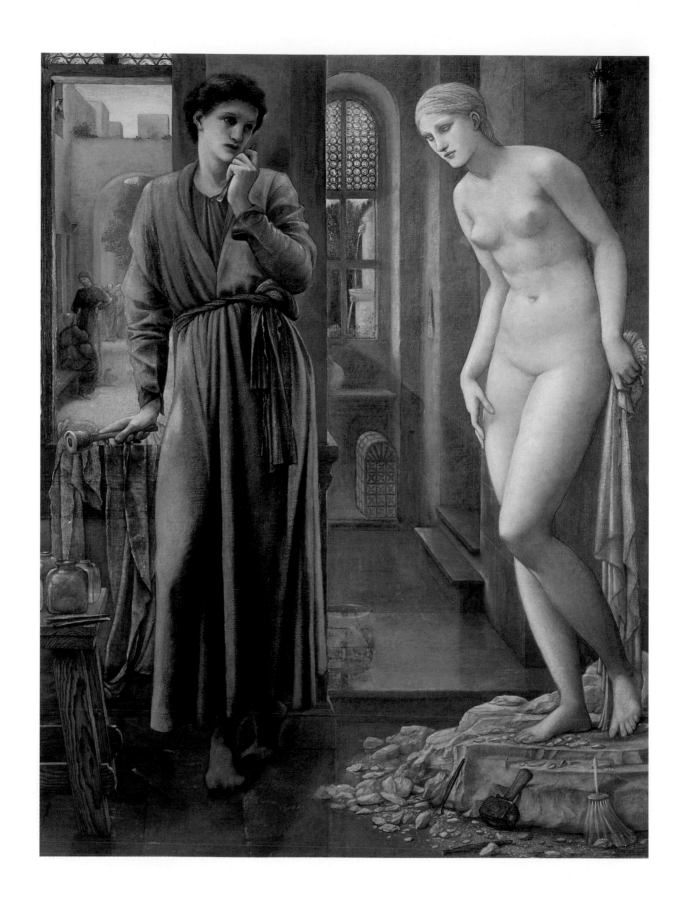

Pygmalion and the Image II: The Hand Refrains

Plate 20, 1875–1878. Oil on canvas, 39 x 30 in. (99.1 x 76.2 cm). Birmingham Museums and Art Gallery.

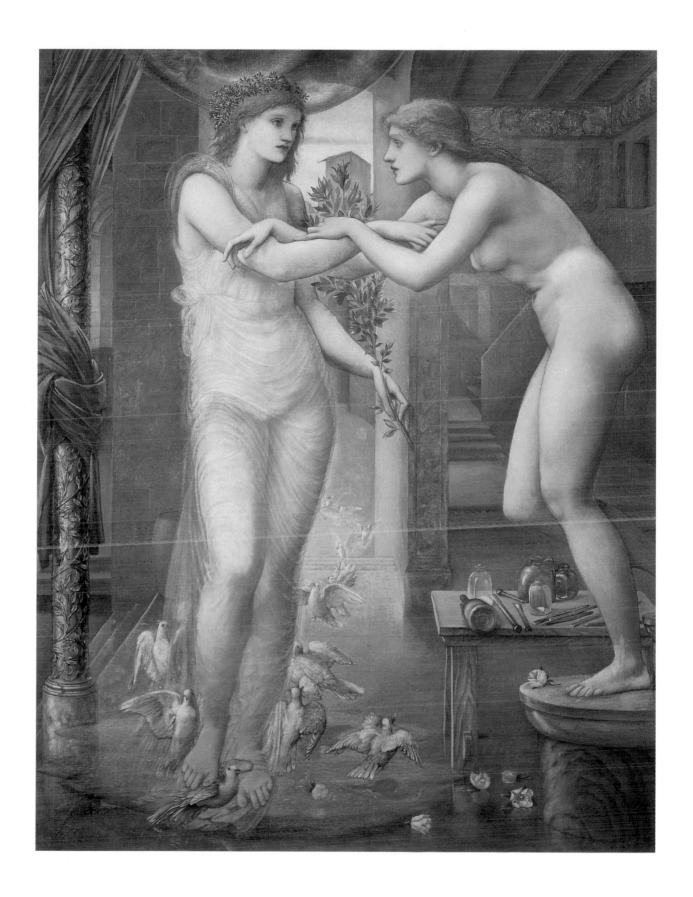

Pygmalion and the Image III : The Godhead Fires

Plate 21, 1875–1878. Oil on canvas, 39 x 30 in. (99.1 x 76.2 cm). Birmingham Museums and Art Gallery.

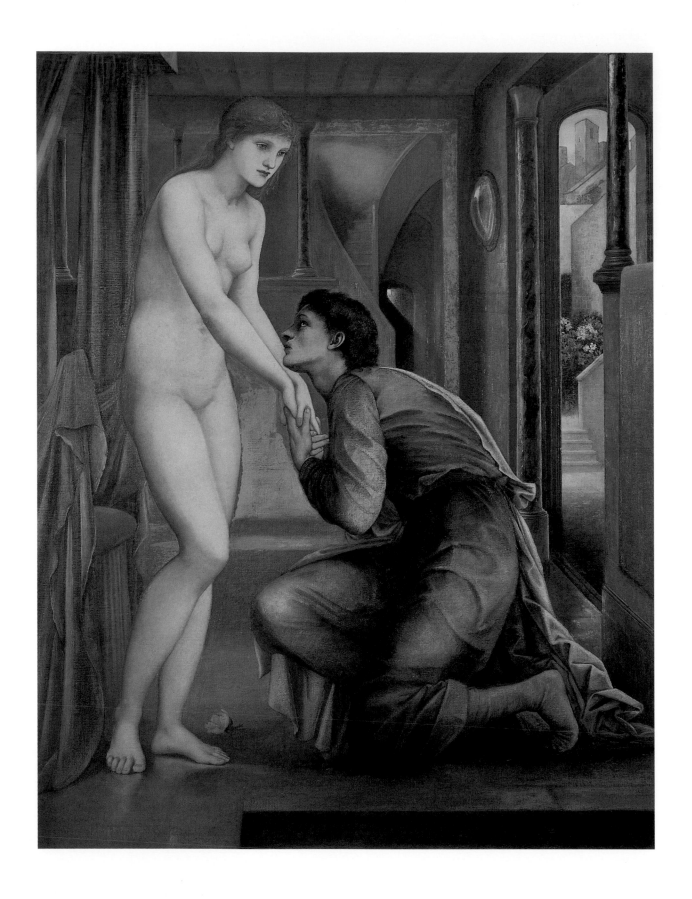

Pygmalion and the Image IV: The Soul Attains

Plate 22, 1875–1878. Oil on canvas, 39 x 30 in. (99.1 x 76.2 cm). Birmingham Museums and Art Gallery.

his statue come to life. The earlier works have a somber palette, as darkly romantic as his medieval watercolors. The figures there are as heavily draped as statues carved into the columns of cathedrals. By contrast, the tone in the later cycle is lighter, more sparkling, metallic and subtle. The figures are fuller, more plastic. In *The Godhead Fires*, for instance, the transparent drape of Venus's gown reveals her Botticellian proportions, while the complicated intertwining of the goddess's and Galatea's arms reflects the interest the artist had in expressing gestural grace. There is no doubt that Burne-Jones felt a kinship with the mythic king, kneeling in wonder before what his own imagination had brought into being.

Having long scorned orthodox exhibition venues, Burne-Jones was lured out of isolation by the prospect of presenting his work in a progressive environment. In 1876 Sir Coutts Lindsay, an amateur painter and avid collector, announced his plan to open a gallery that would be committed to displaying a broad range of contemporary art in a congenial yet unconventional setting. He soon built an exhibition hall on the former Grosvenor estate on New Bond Street. The main galleries were large and luxurious, decorated in the Italianate style, with crimson silk damask covering the walls and skylights in coved ceilings illuminating the interior. Rejecting the standard salon practice of hanging paintings in serried rows, crowded edge-to-edge, Lindsay proposed to give each picture space, separated from adjacent works by six to twelve inches. (Present-day practice is to leave ten to fifteen inches on either side.) Lindsay also initiated a daring method of selecting the works to be shown. Rather than asking artists to submit to the judgment of a committee, he simply extended invitations and left the choices to the artists themselves.

With the assistance of hired managers Charles Hallé and J. Comyns Carr, Lindsay compiled an invitation list for the opening of the Grosvenor Gallery that embraced nearly every facet of the Western art world. They approached respected stars of the academy, such as Leighton, Millais, Poynter, and Watts. Artists from the Continent and North America, including Whistler, Alphonse Legros, and Gustave Moreau, were invited, as well as an unusually large number of women, including Evelyn de Morgan and Marie Spartali Stillman. (She had married the American editor William M. Stillman six years earlier.) Practitioners of the new aestheticism such as Albert Moore received invitations, as did little-known romantic visionaries, including John Roddam Spencer Stanhope and John Melhuish Strudwick. And, in a bold move that would make the Grosvenor Gallery the most noticed art venue in London, Lindsay and his assistants sent personal letters of appeal to Dante Gabriel Rossetti and Edward Burne-Jones.

Burne-Jones accepted, and he wrote to Rossetti expressing the hope that they would exhibit together, in defiance of possible critical attack:

> As to the Grosvenor, if you have made up your mind we won't talk about it. I should have liked a fellow-martyr—that's natural—as I shall feel very naked against the shafts, and as often as I think of it I repent promising, but it doesn't really matter—the worst will be temporary disgrace, and one needn't read criticisms.

But Rossetti could not be persuaded. To counter rumors

that ill health had ended his productivity, he sent a letter to the *Times* of London in which, addressing Lindsay, he stated that while he preferred not to participate, he wished the new venture well: "Your scheme must succeed were it but for one name associated with it—that of Burne Jones—a name representing the loveliest art we have." Rossetti was not alone in believing that his friend's new work would astonish the public. "I expect [Burne-Jones] to extinguish almost all the painters of the day," Watts wrote to his friend Charles Richards. "In some respects nothing so beautiful has ever been done, so you may prepare yourself for being knocked off your legs."

The Grosvenor Gallery opened in May 1877 with a week of festivities, each event fully covered by the press. The art critic William Michael Rossetti (the painter's younger brother) commented on the admirable breadth and audacity of the exhibition, unparalleled in his memory: "There are the illustrious, the skillful, the mediocre, and the obscure, natives and aliens, professionals and amateurs, excellent artists present, and other excellent artists absent."

Burne-Jones had submitted eight works, which were hung together on a wall in the main room. A six-panel watercolor, *The Days of Creation*, provided the centerpiece. Flanking it were two large oils, *The Mirror of Venus* and *The Beguiling of Merlin*. Five smaller allegorical and figural works—*Temperantia*, *Fides*, *Spes*, *St. George*, and *A Sibyl*—were hung above. Never had Burne-Jones's work been so fully represented or so sympathetically displayed. Thoughtfully, Lindsay placed four paintings by Watts on the opposite wall, including the grand allegory *Love and Death* (1875) and his 1870 Burne-Jones portrait.

Rossetti's and Watts's predictions about the reception Burne-Jones would receive proved to be accurate: He emerged as the chief sensation of this sensational exhibition. Oscar Wilde was one of many critics who credited Lindsay's rediscovery of the artist, effusively declaring Burne-Jones to be the presiding genius of the Grosvenor Gallery, "one great master of painting, whose pictures had been kept from public exhibition by the jealousy and ignorance of rival artists." Henry James called him "the lion of the exhibition," declaring that "In the palace of art there are many chambers, and that of which Mr. Burne-Jones holds the key is a wonderful museum." The artist was stunned by such responses. He paid little heed to the praise his works elicited, however, instead worrying that the strong red damask of the gallery walls did not show his paintings to their best advantage. In retrospect, Georgie acknowledged that the exhibition marked the turning point in her husband's career: "From that day he belonged to the world in a sense that he had never done before, for his existence became widely known and his name famous."

The ensemble of large paintings exhibited at the Grosvenor Gallery revealed the magnitude of Burne-Jones's expressive imagination. In the lyrical *Mirror of Venus* (1870–76; Plate 23), nine women gather around a glassy pond to view their reflections. Venus stands among them, presiding over her comely court. The rocky terrain recalls the Tuscan landscape of Florentine painting, and the pliant postures of the women as they lean over the water epitomize classical grace. As in *Green Summer* of 1868 (see Plate 9), Burne-Jones regards beauty as his sole subject. No narrative is needed to enhance the work. By contrast, *The*

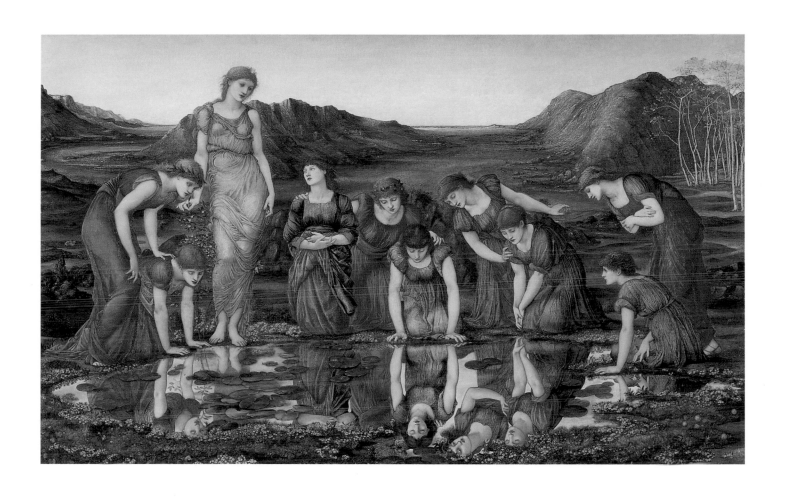

The Mirror of Venus

Plate 23, 1870–1876. Oil on canvas, 47¼ x 78¹¹⁄₁₆ in. (120 x 199.9 cm). Calouste Gulbenkian Foundation Museum, Lisbon.

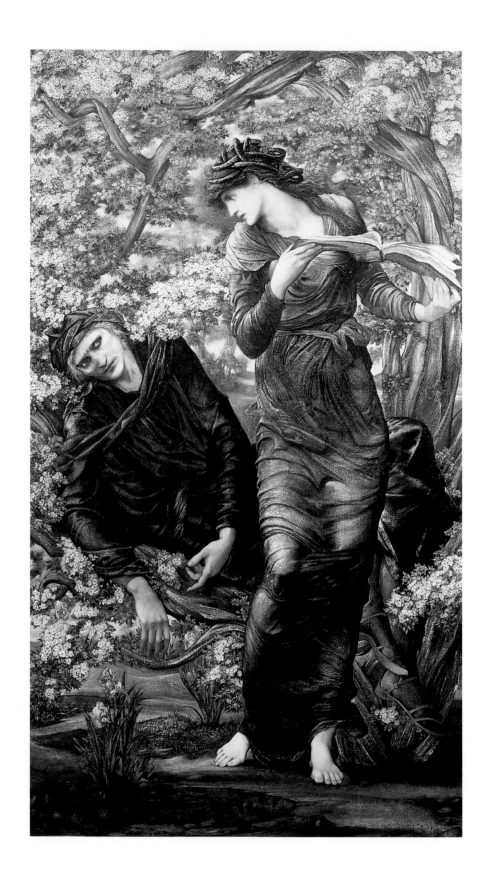

The Beguiling of Merlin

Plate 24, 1874–1876. Oil on canvas, 73 x 43½ in. (186 x 111 cm). The Board of Trustees of the National Museums and Galleries on Merseyside (Lady Lever Art Gallery, Port Sunlight).

Beguiling of Merlin (1874–1876; Plate 24) portrays a provocative tale from the Arthurian legend. Nimuë, the Lady of the Lake, has pursued Camelot's wizard into the wood, hoping to learn his secret spells. Lulled into submission by her promise to satisfy his every desire, Merlin relinquishes his ancient book of enchantment. Nimuë then betrays him, using his own magic to drain his powers and imprison him for eternity in the flowering branches of the hawthorn tree. With her tall, twisting form, Nimuë embodies the fatal woman. She relishes her dominance over her languid victim and vibrates with the strength of her spell. As passionate and dynamic as *The Mirror of Venus* is chaste and tranquil, *The Beguiling of Merlin* exhibits Burne-Jones's dramatic power. The viewer is as seduced by Nimuë's sensual beauty as the hapless Merlin.

The design of *The Days of Creation* (1870–1876; Plates 25–27) was inspired by the Old Testament description of the vision shared by Shadrach, Meshach, and Abendnego in the fiery furnace that revealed how the universe had been brought into being. Burne-Jones first conceived the image in 1874 as a set of stained-glass panels for Tamworth Church in Staffordshire. He returned to the idea in 1876 and, over the span of ten months, painted six highly detailed watercolors on linen, embellished with gouache and shell gold. The tall, narrow paintings were installed in a massive horizontal frame, unifying them into a single ensemble. The effect of the six panels—with their glimmering opaque surfaces, shining like jewels within their heavy setting—was that of an altarpiece, a shrine to divine creation.

Each panel is dominated by a somber and stately angel

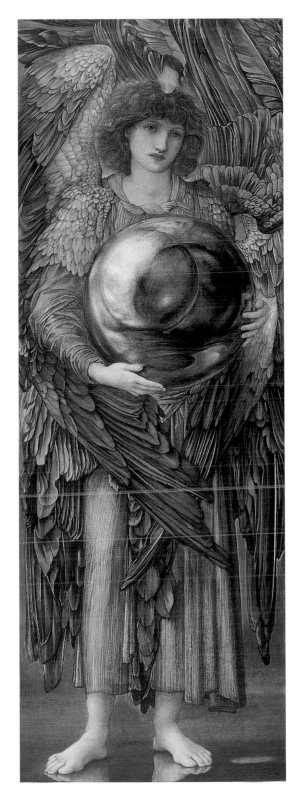

The Days of Creation: The First Day

Plate 25, 1870–1876. Watercolor, gouache, shell gold, and platinum paint on linen-covered panel, 40⅛ x 14 in. (102.2 x 35.5 cm). Courtesy of the Fogg Art Museum, Harvard University Art Museums, Bequest of Grenville L. Winthrop.

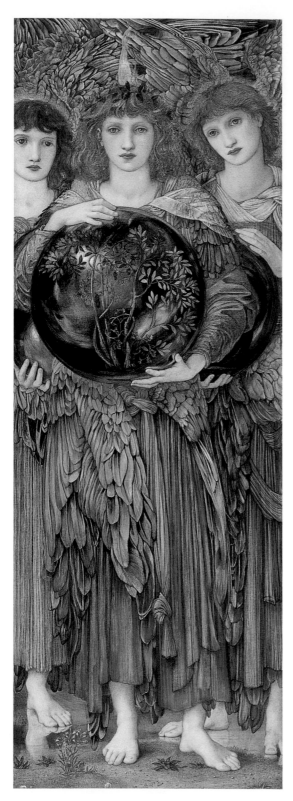

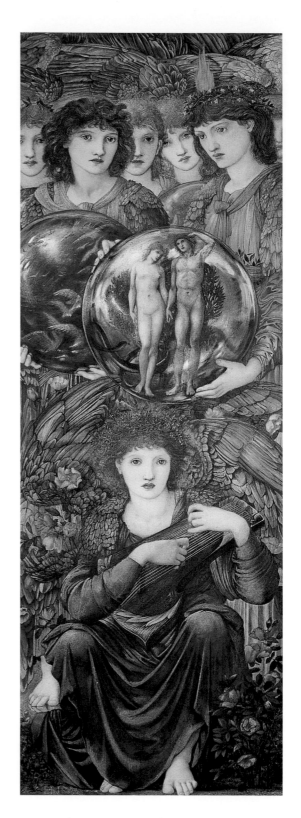

The Days of Creation:
The Third Day

Plate 26, 1870–1876. Watercolor, gouache, shell gold, and platinum paint on linen-covered panel, 40¼ x 14⅛ in. (102.2 x 35.9 cm). Courtesy of the Fogg Art Museum, Harvard University Art Museums, Bequest of Grenville L. Winthrop.

The Days of Creation:
The Sixth Day

Plate 27, 1870–1876. Watercolor, gouache, shell gold, and platinum paint on linen-covered panel, 40¼ x 14³⁄₁₆ in. (102.3 x 36 cm). Courtesy of the Fogg Art Museum, Harvard University Art Museums, Bequest of Grenville L. Winthrop.

who holds forward a globe representing the Lord's individual works during Creation: separating the light from the darkness, bringing order out of chaos, dividing the land from the water, placing the sun and moon in the heavens, drawing life from the waters, and creating humanity. The composition is both progressive and cumulative. In the first panel, the lone celestial figure looms out of a subdued background, garbed in a gown and folded wings of cool blues and grays. As the vision unfolds and a new angel appears, the previous angels withdraw to the background, so that in each panel the number of angels corresponds to the given day during the week the world was made. Burne-Jones enhanced his iconography with color, moving from cool tones to warm ones, adding lavender, turquoise, gold, coral, and rose to his palette in successive panels to convey the accumulating richness of Creation. In the panel representing the sixth day, a glowing angel crowned by flame displays man and woman, made in the image of the divine. Within the translucent sphere, the tranquil forms of Adam and Eve dwell in ease and innocence. But the sinewy serpent is also present, coiled and ready to strike. Below the sphere, another angel kneels among blooming rose bushes, playing a zither to soothe the Creator on the seventh day, the day of rest. In these six panels, Burne-Jones presents an epic vision. Serene, silent, and reverent, *The Days of Creation* reveals the spiritual mystery of Creation through its celebration of aesthetic beauty.

While critics typically hailed Burne-Jones's reappearance before the public as a triumph, his work in the 1877 exhibition also drew the "shafts" he had forecast in his letter to Rossetti—some of which came from the very writers who praised him. James, for example, found troubling elements in his art, pondering whether his "lionship" depended too much on "his 'queerness'" and "a certain air of mystery which had long surrounded him." The novelist-critic remarked as well on the sexual ambiguity of Burne-Jones's figures. Describing *The Days of Creation* in his review, he initially referred to the angels as female figures, but then observed that "perhaps they are young men; they look indeed like beautiful, rather sickly boys" and speculated that they might be "sublimely sexless, and ready to assume whatever charm of manhood or maidenhood the imagination desires." The figures' introspective mood proved to be another source of critical contention; rather than being read as reflecting reverence, it was perceived as signaling malaise, prompting a writer in the *Art Journal* to notice "a funereal sadness" in the faces of the angels, "as if they had all been assisting at a great melancholy blunder."

The Grosvenor Gallery's stunning premiere exhibition established it as a secure venue for advanced art in London. And, despite the few notes to the contrary, Burne-Jones was widely recognized as central to that success. He returned to the gallery for its 1878 display, this time submitting eleven works, including the set of allegorical panels depicting day, night, and the four seasons that he had painted for Frederick Leyland (see Plates 14–17) and the large oil version of *Le Chant d'Amour* (see Plate 13). Again his work was lauded, but again, too, critics detected disturbing elements in his beautiful visions.

Nowhere was this more evident than in reactions to the painting *Laus Veneris* (1878; Plate 28). A portrayal of Venus

at rest in her court, the painting was inspired by the poem of the same title by Algernon Charles Swinburne that was included in his debut collection, *Poems and Ballads* (1866). The book was dedicated to Burne-Jones; the two had been friends since the poet's college days, having met while the artist was working on the Oxford Union murals. Swinburne's passionate verse, an invention on the medieval Tannhäuser legend, spun an extended reverie of sexual surrender in which the knight recalls his hours of pleasure in Venus's palace: "Her beds are full of perfume and sound, . . . With tears whereby strong souls of men are bound." Swinburne's provocative celebration of sensual pleasure in this and his other poems made him notorious, and critics condemned the volume as erotic and blasphemous. Little wonder that when Burne-Jones painted a work bearing the same title as the infamous poem, he was charged with the same sensualist spirit.

Reclining among her handmaidens, Burne-Jones's Venus seems weary. Her languid posture and distracted expression suggest that she is lost in thought, barely hearing the music that is being played for her pleasure. The tapestries covering the walls of her palace show a triumphal procession in which women hand her apples (a symbol of her domain in Cythera) and her son, Cupid, stands guard on her chariot, ready to let fly an arrow of love. A group of knights in silvery armor pass her window and gaze longingly into her chambers. The mood of *Laus Veneris* is brooding, almost mournful, reminiscent of the poignancy conveyed in *Le Chant d'Amour*. But many critics allied this mood with the message of the poem and branded both as decadent. Frederick Westmore, writing for the magazine *Temple Bar*, condemned this vision of Venus as "ghastly," possessed of "a soul that has known strange tortures, a body that has writhed with every impulse of sickness." Henry James, too, took offense. In a review for *The Nation*, he saw this Venus as a woman "who has had what the French call an 'intimate' acquaintance with life." The critic for the *Spectator* likewise lamented the artist's choice of subject, saying he would hesitate to explain it "to child or wife." "The weariness of satisfied love, and the pain of unsatisfied longing," he continued, "is hardly a theme to expend such magnificent painting upon."

But Burne-Jones saw beauty in longing and desire, and in the expression of beauty the body and spirit were, for him, one and the same. As he had told Rossetti, "one needn't read criticisms." While some critics might misread his intentions, their words did not diminish his own faith in his pictures. He now felt able to give tangible form to the elusive visions he held in his imagination. And that, as far as he was concerned, was the only fair standard by which to measure his art.

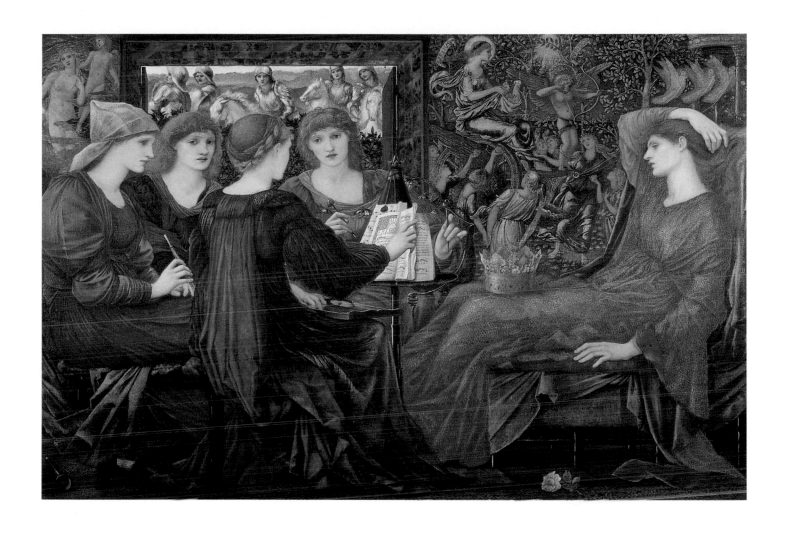

Laus Veneris

Plate 28, 1878. Oil on canvas, 48¼ x 72⅛ in. (122.6 x 183.2 cm). Laing Art Gallery, Newcastle upon Tyne, Tyne and Wear Museums, England.

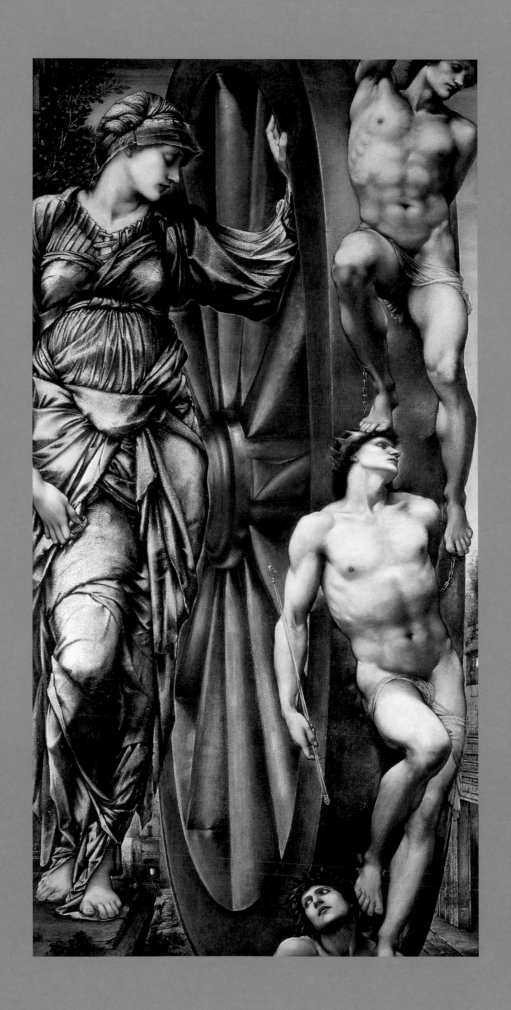

ON FORTUNE'S WHEEL

With characteristic caution—and more than a little reluctance—Burne-Jones accepted his newfound fame. In the spring of 1878, after sending eleven pictures to the Grosvenor Gallery, he traveled to Paris, where *The Beguiling of Merlin* (see Plate 24) was exhibited at the Exposition Universelle. Back in London, invitations from all sectors of society drew him into an ever-widening circle, which now included Henry James, Oscar Wilde, the actress Ellen Terry, and even Prime Minister William Gladstone and his daughter, Mary. In response, the Burne-Joneses began to entertain

in a modest way. Although the artist disdained the fashion of receiving guests in the studio on Sundays, Georgie willingly kept a weekly open house on that day with Morris as a regular at the breakfast table. Young artists were always welcome, and Burne-Jones never refused to look at their work "for fear of turning away an angel." Georgie recalled that her husband entered fashionable society "by degrees," but that his "most was not much." He remained distrustful of what he called public life; the irony of having worked for more than twenty years and then being declared an overnight sensation did not elude him.

In the midst of these changes, fortune emerged as a powerful icon in Burne-Jones's art. The subject of the Wheel of Fortune first appeared as a minor element in *The Troy Triptych* (c. 1870), a complex scheme depicting events leading up to the Trojan War. Burne-Jones never carried out his plan, but a painted sketch dated 1870, likely the work of studio assistants, documents the design. In the sketch, the three main panels depict the Feast of Peleus. During the feast, Discord casts a golden apple inscribed "For the Fairest" into the crowd; Juno, Minerva, and Venus each claim it as her own. This was the first in the series of incidents that led to the war. In the predella below the main panels, the central image features the Judgment of Paris. On one side is Venus Concordia, the goddess of love, presiding with the three Graces; on the other is Venus Discordia, whose court is disrupted by the four Vices. Between these panels are four small allegorical figures: Love, Fame, Oblivion, and Fortune.

Burne-Jones painted more than five versions of *The Wheel of Fortune*. The largest—and clearly the finest—was displayed in the Grosvenor exhibition of 1883 (Plate 29). In all versions, he depicts Fortune as a grand, quietly dignified figure, standing with her head bowed and her left hand lightly resting on a rough wooden wheel. In characterizing Fortune this way, Burne-Jones joined a venerable tradition. With origins in classical antiquity, the image of Fortune's Wheel—by turns toppling kings and raising beggars—endured throughout the Middle Ages in diverse sources ranging from the Tarot to the *Hortus Deliciarum* of Gerrad of Landesberg to the Arthurian legend.

Three male figures writhe as the wheel begins to turn: a slave bound in leg irons, a king with crown and scepter, and a hero wreathed in laurel. Nearly nude, their massively proportioned physiques reveal Burne-Jones's full assimilation of Michelangelo's aesthetic. During his stay in Rome in 1871, he studied the Sistine Chapel ceiling through opera glasses for hours while he sprawled on his back on the floor. The figure of Fortune resembles the majestic sibyls in that fresco cycle, while the male figures, expressing their emotional state through muscular contortion, recall the *Captives* Michelangelo sculpted for the tomb of Pope Julius II, which Burne-Jones sketched during the same visit.

The sense of detachment expressed by Burne-Jones's figure of Fortune is linked to the medieval belief that fortune, although impassive, was an agent of divine judgment. Fate, more than chance, defined destiny. Changes of fortune were meant to test human character, a series of trials that were an inevitable part of the human condition. As Burne-

Jones adjusted to his newfound fame, the cautionary message of fortune's mutability took on a deeply personal meaning. Even ten years later, when he described the work to his friend Helen Mary Gaskell, he confided, "My Fortune's wheel is a true image, and we take our turn at it, and are broken upon it."

The yearly deadline for the spring Grosvenor Gallery exhibition interfered with Burne-Jones's slow and deliberate working methods. This deadline, coupled with the rising demand for his work, exhausted him. He sent only one picture to the 1880 show, completing it just a week before the opening. "The picture is finished," Georgie recorded in her diary on April 22, "and so is the painter almost. He has never been so pushed for time in his life."

The tranquil atmosphere of that canvas, *The Golden Stairs* (Plate 30), betrays no evidence of the pressure under which it was completed. Designed in 1872 and begun in 1876, it harks back to the lyricism of works such as *Green Summer* (see Plate 9), evoking mood rather than narrative. In fact, he had considered two other titles for the painting—*The King's Wedding* and *Music on the Stairs*—but his final choice reflects his desire not to use the image to tell a story. Eighteen young women, each carrying a musical instrument, descend a curving staircase. Even though many of them turn to share a glance or a smile, the atmosphere is hushed. Where they have come from, where they are going are of no consequence. The painter is only interested in their beauty and grace. When puzzled viewers questioned Burne-Jones about the meaning of the work, he refused to offer any explanation.

He explored subtle color harmonies in *The Golden*

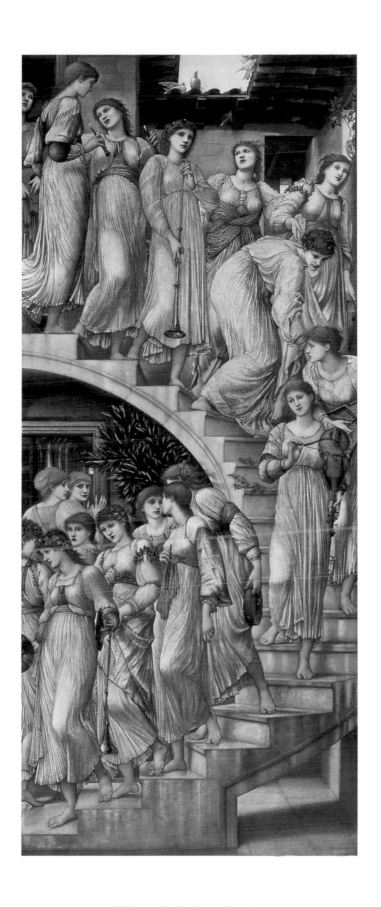

The Golden Stairs

Plate 30, 1872–1880. Oil on canvas, 106 x 46 in. (269.2 x 116.8 cm). Tate Gallery, London/Art Resource, N.Y.

Self-Caricature as Pavement Artist

Figure 24, n.d. Pen and ink, 4 ½ x 2 ½ in.
(11.4 x 6.3 cm). Inscribed: "Starving."
Courtesy of Sotheby's, London.

Self-Caricature Collapsed on Canvas

Figure 25, from an illustrated letter to Helen Mary
Gaskell, n.d. Pen and ink, 7¼ x 9 in. (18.4 x 22.9 cm).
Courtesy of Sotheby's, London.

Stairs, limiting his palette to pale golden browns, shimmering grays, and silvery blues. These nuanced colors, plus the absence of an explicit subject and the allusion to music, link the painting with Whistler's Symphonies, Nocturnes, and Harmonies of the 1860s and 1870s. The deliberate ambiguity of the work also allied it with ideas arising from the burgeoning Symbolist movement, whose basic impulse was exemplified a decade later by the French poet Stéphane Mallarmé's citing of the enigmatic as essential to aesthetic experience: "To *name* an object is to suppress three-quar-

ters of the enjoyment . . . *suggestion,* that is the dream."

As Burne-Jones had feared, his new renown forced him into a more visible role in the art world. In 1878, for example, he found himself in the uncomfortable position of testifying against Whistler in the libel suit that the American artist had filed against Ruskin over the critic's denunciation of his 1876 painting *Nocturne in Black and Gold: The Falling Rocket.* (Whistler won the case but was awarded a pittance in damages and was left bankrupt.) In 1880 Burne-Jones refused the presidency of the Birmingham Society of Artists, mainly, it seems, because of the annual address required of whoever held that post. As he explained to Morris: "What have I to say that Ruskin or you have not said already?. . . All my habits of labour for many years now have been carrying me further and further from the possibility of easily expressing myself by words." But when asked again five years later to fill the office, he acquiesced—with

the understanding that he would not have to give any public lectures. In 1881 Oxford granted him an honorary degree, and in 1883, with Morris, he was made an Honorary Fellow of Exeter College. He was deeply touched by the university's recognition. In general, however, the rush of public attention had little effect on Burne-Jones. Instead, it inspired self-deprecating humor. He drew caricatures of himself as a pavement artist (Figure 24) or fallen down on his canvas (Figure 25). He even jokingly suggested to Grosvenor Gallery co-manager J. Comyns Carr that he include a view of the artist's notoriously disordered studio in a series Carr was publishing on prominent artists, and sent him a sketch for an illustration (Figure 26).

In 1881 Burne-Jones declined to send any work to the Grosvenor's annual exhibition, a move that prompted Henry James to observe that "A Grosvenor without Mr. Burne-Jones is a *Hamlet* with Hamlet left out." But in the next year's show he was once again well represented, submitting nine works. He returned to old themes, as in *The Tree of Forgiveness* (1881–1882), a reworking of *Phyllis and Demophoön* (see Plate 18), with Michelangelesque bodies draped for modesty. He also introduced new themes, such as the saga of the classical hero Perseus. He was beginning a ten-part cycle of paintings about Perseus's adventures, and an early version of *Perseus and the Graiae* (c. 1882) gave the public a glimpse of what he projected. And from the plans for the *Troy Triptych* he developed designs for two independent paintings, *The Feast of Peleus* (1872–1881) and *Cupid's Hunting Fields.*

Like *The Wheel of Fortune, Cupid's Hunting Fields* first appeared as a personified figure in the predella of the *Troy*

Figure 26, The Studio in the Grange, 1883, from Georgiana Burne-Jones, *Memorials of Edward Burne-Jones* (London: 1904). Photo courtesy of The Newberry Library, Chicago.

Triptych. There, Cupid is a tall, lithe youth who strides forward, drawing his bow. In his three successive versions of *Cupid's Hunting Fields,* painted over nearly five years, Burne-Jones expands the allegory. He blindfolds the son of Venus and places him at the center of a group of five young women, each of whom pulls away from his golden shaft. For the 1885 version (Plate 31), the last of the three, Burne-Jones used only gouache—no gold was applied—but his masterful modulation of a restricted number of tones, including a warm golden brown, a pale ivory, and an icy aqua, made the surface sparkle. Also in this version, each woman responds individually as Cupid prepares his bow—ranging from the cautious figure at the lower left, who recoils, to the curious and eager woman at the right, who is ready to spring away. Cupid's strike, however, will be random: Love, like fortune, rests in the hands of fate.

Burne-Jones joined the forces of fortune and love in his romantic vision of transformed destiny, *King Cophetua and*

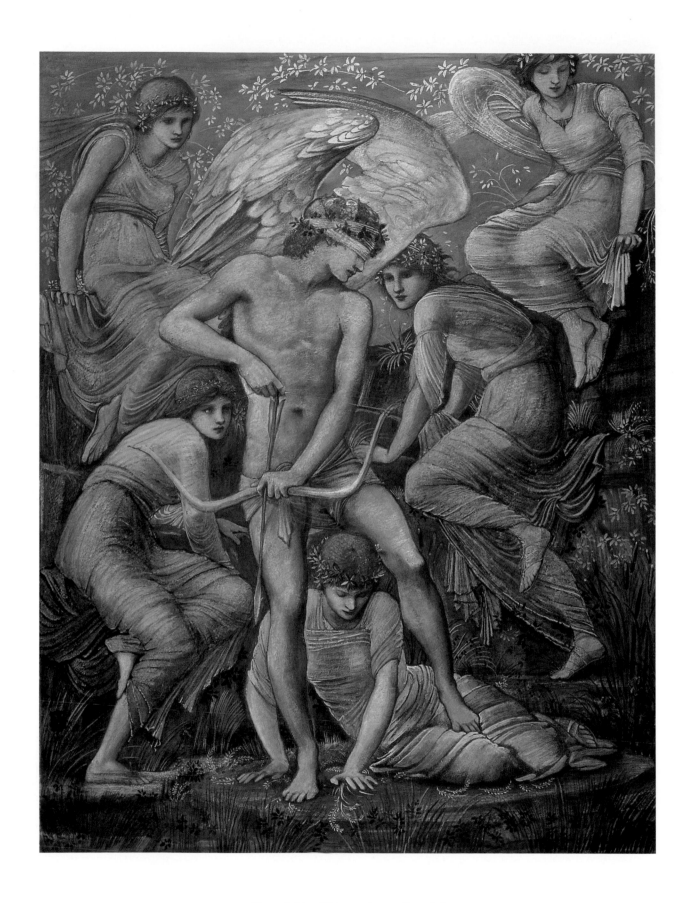

Cupid's Hunting Fields

Plate 31, 1885. Gouache 38¼ x 29⅝ in. (97.2 x 75.2 cm). The Art Institute of Chicago.

the Beggar Maid (1884; Plate 32). The story of the African prince who is willing to give up his kingdom for the love of an impoverished woman had intrigued Burne-Jones since his youth. Although the tale was first told in an Elizabethan ballad, Burne-Jones knew it through Tennyson's version, "The Beggar Maid," which was included in his 1842 collection, *Poems*. As early as 1861, Burne-Jones had painted the subject twice, once as a design for a cabinet by Philip Webb and again in a small oil. Perhaps Morris's poetic masque of 1873, "Love Is Enough," which also tells of a king sacrificing riches for his heart's desire, reignited Burne-Jones's interest in the subject. By 1875, he was sketching ideas for a new interpretation, which he painted on a grand scale in oil and exhibited at the Grosvenor Gallery in 1884.

The scene is set in a richly appointed room, where a beautiful woman sits in wonder on a benchlike throne. She seems afraid to move, and her face betrays her bewilderment. All that is known of her past is poverty, evidenced by her tattered gown, and abandonment, signified by the anemones in her right hand. Seated on the steps below her is a knight. His armor is both fantastic and magnificent, and the crown he holds at his knees reveals his royal station. In a preliminary sketch, Burne-Jones depicted Cophetua in dynamic action, reaching out to the maid in an offer of love. But in the painting, the king is still and self-contained. He gazes on the beggar maid not desirously but contemplatively. Their union will alter their destinies—hers by chance, but his by choice. He has forsaken earthly power and material wealth for spiritual beauty and romantic love.

King Cophetua and the Beggar Maid won rave reviews. Critics hailed the work as evidence of Burne-Jones's technical mastery. In preparing the work, he had paid even more attention to detail than usual, having models made for Cophetua's armor and crown and fretting over the maid's dress. The surface richness of the painting, with its restrained palette, subtle illumination, and painstakingly rendered detail, drove Burne-Jones to distraction. On April 23, he wrote to his friend Mrs. Percy Windham:

> *This very hour I have ended my work on my picture.*
> *I am very tired of it—I can see nothing any more in it,*
> *I have stared it out of all countenance and it has no*
> *word for me. It is like a child that one watches without*
> *ceasing till it grows up, and lo! it is a stranger.*

But Georgie believed that the painting more accurately captured the artist's unique vision than any other. The generally conservative critic for the *Times* of London went further, declaring *King Cophetua and the Beggar Maid* "not only the finest work Mr. Burne-Jones has ever painted but one of the finest pictures ever painted by an Englishman."

Throughout his life, Burne-Jones envisioned the medieval knight as the utmost exemplar of high human endeavor. Whether on a quest, like Sir Galahad, or on an adventure, like St. George, the knight embodied a man's singular power to challenge fortune and change destiny. Although Cophetua was an African king, Burne-Jones portrayed him as a medieval knight, rescuing a damsel from her dire fate. Ever romantic, and always believing in the power of honorable intentions, Burne-Jones used the image

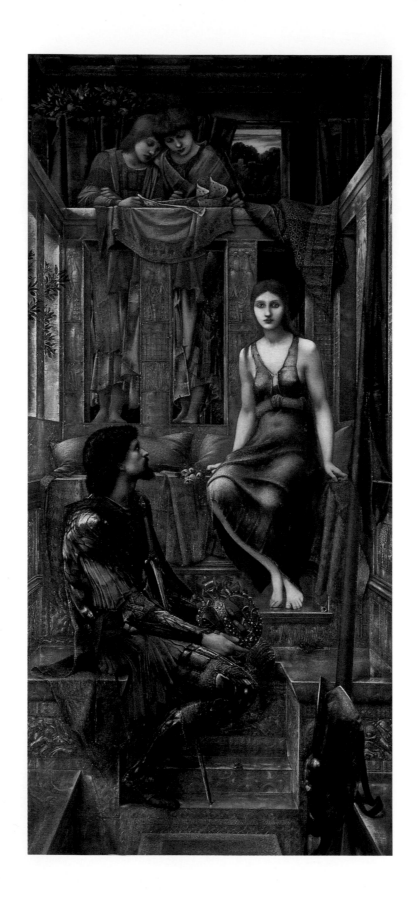

King Cophetua and the Beggar Maid

Plate 32, 1884. Oil on canvas, 115½ x 53½ in. (293.4 x 135.9 cm). Tate Gallery, London/Art Resource, NY.

of the knight in armor to symbolize what he saw as the best of masculine spirit: bravery, dedication, and heroism. It is not surprising, then, that when he began his series on the legends of Perseus, he transformed that Greek hero into an agent of medieval chivalry.

In 1875 his patron Arthur Balfour commissioned a set of paintings from Burne-Jones for the music room of his London home. As he often did at this time, the artist turned for a subject to Morris's large-scale poetic epic *The Earthly Paradise*, choosing the adventures of Zeus and Danae's son, Perseus, who beheads the Gorgon Medusa and rescues the maiden Andromeda. The original plan called for ten large oil paintings to be installed in the music room and for Morris to decorate it. The interior-design scheme was never realized. And though Burne-Jones painted large gouache cartoons of all the planned subjects, he completed only four of the oils, working from 1885 to 1888.

Of the four finished oils, three featured incidents from the rescue of Andromeda. After Perseus has killed Medusa, he travels to Joppa in Ethiopia, where he finds the beautiful young Andromeda chained to a rock by the sea. Her mother, Queen Cassiopeia, has angered Poseidon, and she is willing to sacrifice her daughter to a sea monster in order to appease him. Burne-Jones portrayed Perseus finding Andromeda in *The Rock of Doom* (1885–1888; Plate 33) and then battling the monster in *The Doom Fulfilled* (1888). Locked in combat with the coiling beast, Perseus appears as a romantic knight in armor. The shining surfaces of his fantastic black armor, which turns his body into a hard projected weapon, contrast with the tender vulnerability of Andromeda's nude body. Only the winged sandals on

Perseus's feet, a gift from the god Hermes, remind the viewer of the classical origins of the tale. In form, in detail, and in the clear-cut roles of the active man and the passive woman, Burne-Jones imagined Perseus's rescue of Andromeda as a medieval romance.

To counter the public demands of his professional success, Burne-Jones carefully cultivated his privacy. In 1880 he purchased a second home, North End House, in Rottingdean. Located on the coast near Brighton, it was less than sixty miles from London, but it offered a welcome retreat. He also found solace in pursuing personal projects never intended for public display. The most notable of these was *The Flower-Book*, begun in 1882, with additions made intermittently until the end of his life. Burne-Jones undoubtedly based his idea on then popular guides to the language of flowers. But rather than following the meanings typically assigned to each bloom, he selected only the most intriguing names and used them as points of departure for imaginative illustrations. For instance, *Love in a Mist* (after 1882; Plate 34) presents a red-winged man, bound in vaporous ribbons, struggling to be free, while *Golden Thread* (after 1882; Plate 35) portrays Theseus as a medieval knight, wending his way through the Labyrinth. During his lifetime, Burne-Jones shared *The Flower-Book*, which ultimately grew to thirty-eight watercolors, only with Georgie and a few close friends. Naming it his *Secret Book of Designs*, he willed it to the British Museum. In 1905, seven years after her husband's death, Georgie permitted a limited edition containing the entire set to be published.

His artless sense of humor helped him keep his person-

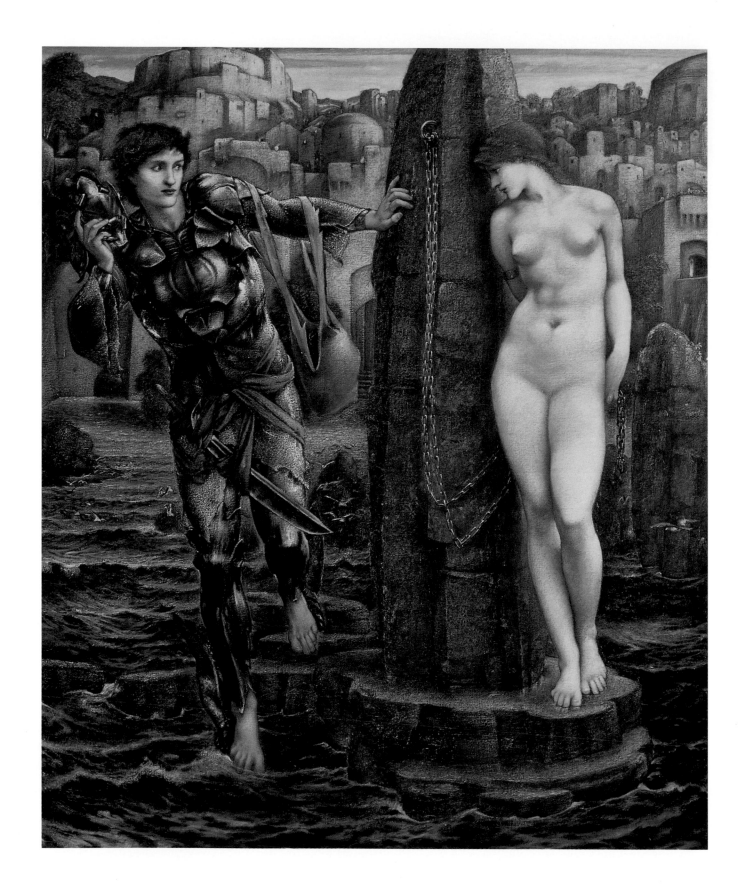

The Perseus Series: The Rock of Doom

Plate 33, 1888. Oil on canvas, 61 x 55¼ in. (154.9 x 140.3 cm). Staatsgalerie, Stuttgart.

Love in a Mist

Plate 34, after 1882, from *The Flower-Book* (London: 1905). Photo courtesy of The Newberry Library, Chicago.

Golden Thread

Plate 35, after 1882, from *The Flower-Book* (London: 1905). Photo courtesy of The Newberry Library, Chicago.

al perspective. He disarmed friends with the earnest greeting, "Are you happy?" He loved to exaggerate his age, claiming to be 97 in 1889 and, five years later, demanding 485 candles for his birthday cake. He warned his son, Philip, to prepare for his decrepitude: "I shall have to be fastened into a chair and given things to play with." Never losing his childish pleasure in pranks, Burne-Jones often sketched "surprise pictures" on the backs of pieces of stationery, which he left for others to use. But he did not make these drawings only on his own stock. As he once gleefully recounted to his studio assistant Thomas M. Rooke: "I went to call on Mrs.__ and she wasn't in and I was left alone in the drawing-room—so I took a new sheet of paper out of the writing table and drew a fat head on the back of it and

put it quietly back again." Letters to close friends almost always featured caricatures, lampooning social snobs, fat women, and—most often—himself.

Burne-Jones cherished his relationships with children. He was a devoted father to his growing offspring, particularly to Margaret, and he never tired of her company, whether in the nursery or in his studio. When Margaret became too old for his picture stories, he struck up a lively correspondence with the daughter of his friends George and Elizabeth Lewis. From 1883 to 1886, Burne-Jones wrote to little Katie regularly, sharing his adventures in words and pictures and signing himself "Mr. Beak," a reference to his prominent nose. He wrote how Margaret was teaching him to draw and dance. He boasted that he saved

a cat and a dog when it was "raining cats and dogs." In a series of letters he told Katie that Margaret offered to share her cat with him: "I am to have the tail end if I am good." For one of the accompanying pictures, he drew himself and his daughter, each with their half of the cat, until he misplaces his end, forcing Margaret to confine him to a corner (Figure 27). During this time, Burne-Jones painted a portrait of Katie reclining on a couch and reading a storybook open to an illustration of St. George (1886; Plate 37). His approach is unorthodox for the Victorian times. He presents no pretense, no posture of coy sentimentality—just the informal image of a child indulging her own imagination.

In 1885 the Royal Academy elected Burne-Jones an Associate Academician. His friends gave him conflicting advice. Frederic Leighton and George Frederick Watts encouraged him to accept the affiliation, while William Morris urged him to reject it. In the end, he accepted the honor with reluctance. Although he was touched that Briton Riviere, an artist he did not know, had placed his name in nomination, he worried that the academy was responding to his fame rather than demonstrating sympathy with his art. He also worried that the act betokened disloyalty to the Grosvenor. Still, he chose not to send any

Wake, Dearest!

Plate 36, after 1882, from *The Flower-Book* (London: 1905). Photo courtesy of The Newberry Library, Chicago.

pictures to the spring exhibition that year, having "begun so many and finished none." He regarded the respite as a relief: "It is so delightful that I have a mind to repeat the experiment for good."

Burne-Jones used his exhibition privilege at the Royal Academy only once. In 1886 he submitted the oil painting *The Depths of the Sea*, which he replicated in a large watercolor the following year (1887; Plate 38). The work features a shocking image of a passive man being dragged to a watery grave by a mermaid who wears an enigmatic smile. Burne-Jones enjoyed painting this challenging image, employing lights submerged in a water tank to simulate the illumination. But, perhaps because he was anxious about how the work would be received in such a conventional exhibition, he asked Leighton, now president of the Royal Academy, to look at the oil before it was finished. His friend suggested only that, for contrast and a touch of whimsy, Burne-Jones add the little school of silvery fish in the upper-right corner. Burne-Jones had worried without reason: His work was as well received at the academy as earlier efforts had been at the Grosvenor. The poet Gerard Manley Hopkins praised the canvas as "the stroke of true artistic genius."

Success did not alter Burne-Jones's discomfort with exhibition societies and their practices. In 1886, when he was

invited to rejoin the Old Water-Colour Society, he declined. He felt "honour bound" to participate at the Grosvenor and "duty bound" to show at the Royal Academy, but his preference was clearly not to exhibit at all. He confessed to Georgie, "I hate Exhibitions and look on them as destructive of aim and resolution and the necessary peace of all lasting work."

Having moved into the center of the English art world, he began now to make a retreat. In October 1887, he wrote to Sir Coutts Lindsay, severing all ties with the Grosvenor Gallery. He was upset by the new directions—commercial advertising, renting out the gallery spaces for club meetings, parties, and concerts—that the enterprise was taking. Central to his decision, however, was the nagging feeling that exhibition demands rather than artistic desires were controlling his art. "I should of all things love to keep out of publicity for a while," he told Georgie, "not exhibiting anywhere, but quietly finishing my work without hurry." He also worried that his actions would be misunderstood, lamenting to his friend George Howard, "It seems that I am always resigning something or other, though I should have said I was a peaceable fellow enough." But he neither regretted nor changed his decision. To protect his artistic vision, he was more than willing to challenge fortune and defy the demands of change.

MY HALF MARGARET'S HALF

Sharing the Cat

Figure 27, n.d., from *Letters to Katie* (London: 1925). Photo courtesy of The Newberry Library, Chicago.

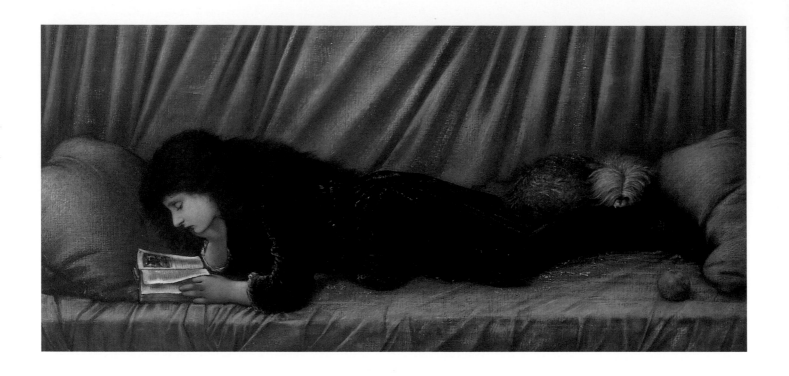

Portrait of Katie Lewis

Plate 37, 1886. Oil on canvas, 24 x 50 in. (61 x 127 cm). Courtesy of Sotheby's, London.

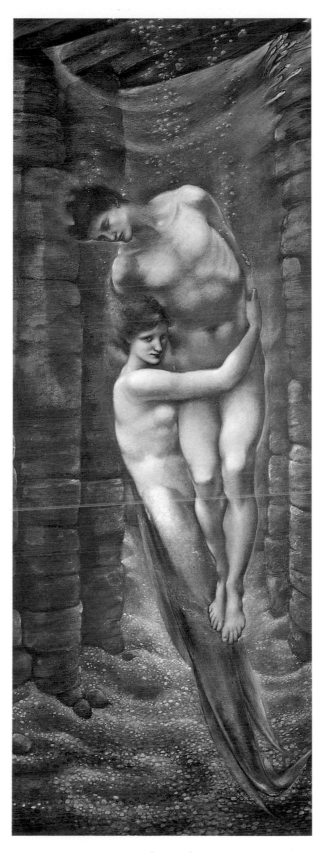

The Depths of the Sea

Plate 38, 1887. Watercolor and gouache on paper mounted on panel, 76¼ x 29 in. (193.7 x 73.7 cm) (site measurement).
Courtesy of the Fogg Art Museum, Harvard University Art Museums, Bequest of Grenville L. Winthrop.

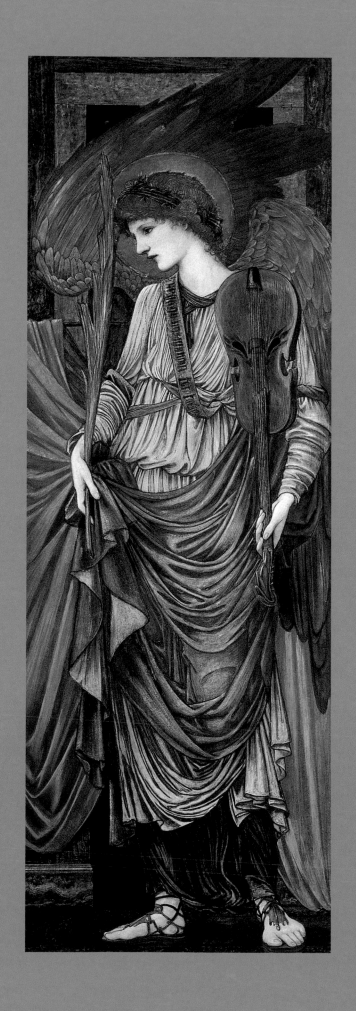

VISIONS AND REVELATIONS

The romantic fascination Burne-Jones held for medieval Christianity in his student days remained with him for the rest of his life. He was not religious in any conventional sense. He rarely attended church and had little patience for modern preaching and parish society. Yet he was captivated by what he called "Christmas carol Christianity," explaining that "There are only two sides of Christianity for which I am fitted—the carol part and the mystical part." The "carol" part—the trappings, relics, and rituals—delighted him, while the "mystical"— the miracles, prophecies, and symbols—

enthralled him. Burne-Jones viewed the biblical world as a wondrous realm, a spiritual mythology based on mystery rather than theology. As in his reverence for beauty in art, he sought neither to define nor debate the nature of faith; he wanted only to believe in its inexplicable power to touch the soul and inspire the imagination.

As a young artist starting out in London, Burne-Jones came to rely on the income he earned through designing stained glass and other church furnishings. He enjoyed this work and continued to do it throughout his career. His aspiration, however, was to create large and grand murals for sacred spaces. As he wrote in 1888, "If I could I would work only in public buildings and in choirs and places where they sing." The closest he came to realizing this

goal was in his work on a cycle of mosaics for the American Church in Rome. As the building neared completion in 1881, the architect G. E. Street approached Burne-Jones for designs to cover the walls of the apse and the inner surface of the dome. The project occupied him for many years, and it caused him much frustration as he tried, without leaving England, to monitor the production of the tesserae in Venice and the installation of the mosaics in Rome. Of all the designs produced for the American Church, Burne-Jones liked best his design for *The Fall of Lucifer* (1894; Figure 28), a grave and sinister vision of the fallen angels driven out of heaven into the depths of hell. However, fearing that the congregation would "not know how to take it," he eliminated it from the cycle.

FACING PAGE

Musical Angels

Plate 39, 1878–1896. Gouache on paper mounted on canvas, 64¼ x 22¾ in. (163.1 x 57.8 cm). The Nelson-Atkins Museum of Art, Kansas City, Missouri. Acquired through the generosity of Mr. and Mrs. Milton McGreevy through the Westport Fund.

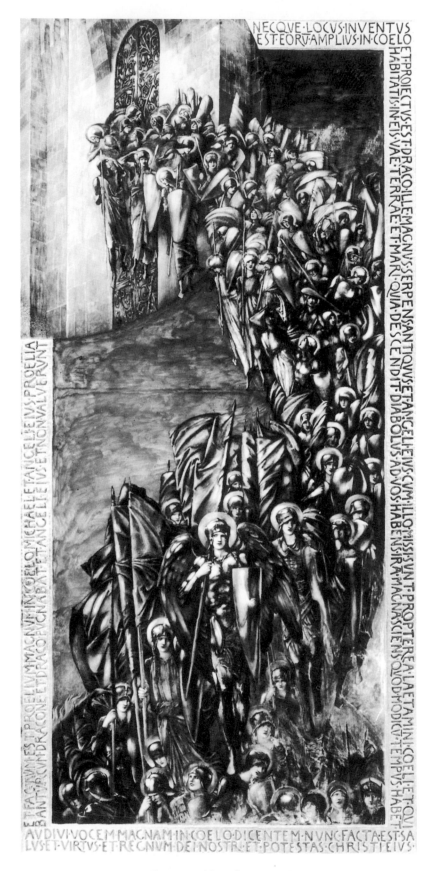

The Fall of Lucifer

Figure 28, 1894. Colored chalks, inscribed in black and gold, 97 x 46½ in. (246.4 x 118.1 cm). Courtesy of Sotheby's, London.

Other major religious commissions followed. In 1886 he designed two windows featuring the Nativity and the Crucifixion for St. Philip's Church in his hometown of Birmingham. But in 1891, when asked to produce mosaic designs to fill the four semi-domes that surrounded the central dome of St. Paul's in London, he declined. Burne-Jones disliked Baroque architecture and found Christopher Wren's grand interior pompous and pretentious. He could not imagine his own designs in a space that "crushed and depressed" him. "It wants carpets hung about," he lamented, "and big, huge, dark oil pictures, and hangings of rich stuffs, and the windows let alone, no stained glass anywhere, . . . Bach always being played, and me miles away." His religious imagination was ignited not by prestige but by piety, as seen in the watercolor of Christ appearing to St. Francis (1887) that he sent to the leper colony on the Hawaiian island of Molokai as a gift for its founder, Father Damien.

Burne-Jones also sought the sacred in secular mythology. This is most evident in his enduring fascination with the saga of Sir Galahad's quest for the Holy Grail. His youthful enthusiasm for the chaste knight never diminished, and late in his life he declared: "Lord! how that San Graal story is ever in my mind and thoughts continually. Was there ever anything in the world as beautiful as that is beautiful?" For Burne-Jones, the quest and its mysterious goal had a deep personal meaning that went beyond the rewards of redemption. In seeking the Grail, Galahad did not question the course he traveled and never doubted the worthiness of his goal. His innocent belief led to the revelation of spiritual mysteries. Burne-Jones saw in

his quest an inspiring model for his own destiny as an artist, seeking enlightenment through artistic vision and pursuing his own Grail in an ideal of beauty always just beyond his reach.

In 1886 Burne-Jones designed a four-light window, which he had Morris and Company fabricate, depicting the end of the quest. Employing a limited ensemble of figures and captions in clear Gothic script, he portrayed how Galahad succeeded while the other knights failed. The panels are joined by a river of light that widens as it flows from left to right toward the sacred chapel. In each, the Grail Angel greets a petitioner: He turns his back on Sir Gawain, who slumbers and dreams of the "Deeds of Kings." He passes over the well-armed Sir Lancelot and a beautiful Queen, recalling "Such Love as Dwelleth in Kings Houses." Galahad earns the Angel's glance, and in the last panel they arrive in the sacred city of Sarras to enter the chapel of the Grail (Plate 40). Burne-Jones's granddaughter, Angela, remembered the curious location of the window in North End House in Rottingdean. Its "jeweled brilliance" shone above a housemaid's sink, "both needed," she observed, and "both a part of daily life."

He also produced a cycle of Grail designs for Morris's Merton Abbey Tapestry Works, commissioned in 1890 by the Australian mining magnate W. K. D'Arcy. The six arras tapestries with additional dado hangings for the dining room of D'Arcy's Middlesex home, Stanmore Hall, allowed Burne-Jones to portray the full narrative, from the Grail Maiden's appearance at Arthur's court to the arming and departure of the knights to his favorite scene, *The Attainment* (1891–1894; Plate 41). At the far left end of

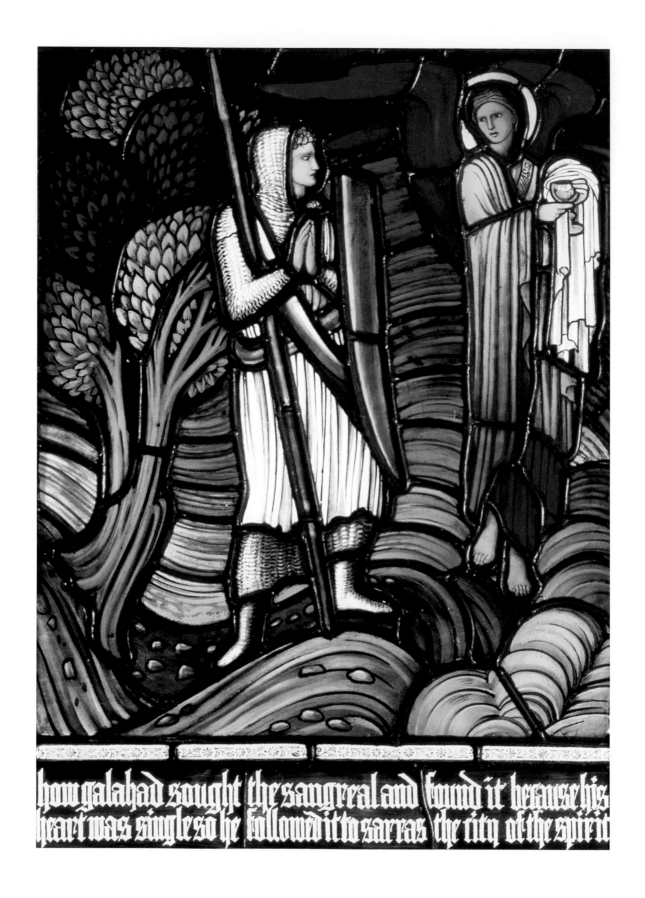

The Story of the Quest for the Sangreal: How Sir Galahad Saw the Sangreal

Plate 40, 1886. Stained-and-painted glass panel. Victoria and Albert Picture Library.

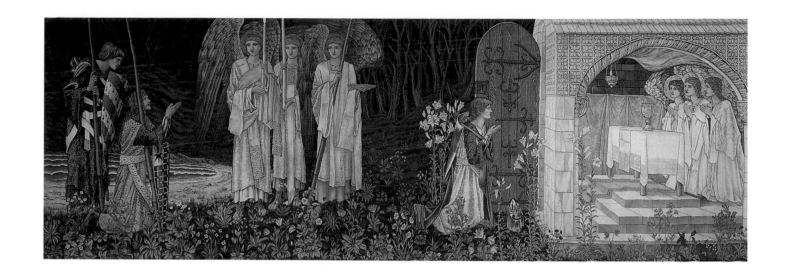

The Quest of the Holy Grail: The Attainment

Plate 41, 1891–1894. Woven by Morris and Company, 1895–1896. Wool and silk tapestry on cotton warp, 96 x 273½ in. (243.8 x 694.7 cm). Birmingham Museums and Art Gallery.

this last and longest panel, Sir Bors and Sir Percival look toward the chapel in the distance, but three tall angels bar their way. Galahad kneels among the blooming lilies outside the chapel. The open door invites the knight to enter, but Burne-Jones makes Galahad pause in reverence before drinking from the gleaming Grail. To Burne-Jones, Galahad's recognition of the Grail was reward enough; to portray the events that followed would betray the mystery by making it material.

Of all biblical subjects, Burne-Jones most favored the Adoration of the Christ Child by the shepherds and the three kings. In Christian belief, the journey taken by the simple farmers and the grand potentates is seen as having cast the matrix for all pilgrimages, including Galahad's quest. The passage through unknown lands to an unimaginable destination appealed to Burne-Jones as a testament to the power of belief. In 1888 he obtained a commission

to paint two large murals that would flank the altar of the church of St. John the Apostle in the seaside town of Torquay. For one side he planned *The King and the Shepherd* (1888; Plate 42) and, for the other, *Nativity* (1888; Plate 43). In the first composition, an empty-handed shepherd dressed in a ragged cloak and a king wrapped in jeweled robes and bearing a golden casket come to the end of their separate paths through a hushed forest. Each is met by an angel, who presses a finger to his lips for silence as they embark on the final stage of their journey. *Nativity* portrays their destination. Mary, attended by three angels bearing the implements of the Passion, reclines with her child on a bolster of rushes beneath the branches of two silver birch trees. Joseph sits at the foot of her rough couch, rapt in wonder, forecasting the homage paid by the shepherd and the king. The rich golden tonality of the painting, including the deliberately arcane use

The King and the Shepherd

Plate 42, 1888. Oil on canvas, 81 x 124 in. (205.7 x 315 cm). Carnegie Museum of Art, Pittsburgh; The Heinz Family Fund, 1997.

of gold for the sky, contrasts with the simple, silent atmosphere. As in *The Attainment,* Burne-Jones felt that quiet recognition, rather than active resolution, was the essential expression of mystery.

As a young man, Burne-Jones had mentioned to John Ruskin that he preferred the shepherds to the kings. But the critic urged him to rethink the matter, pointing out that the shepherds "had everything to gain by coming," while the kings made the greater sacrifice. In 1887 Burne-Jones recalled Ruskin's words when he designed a

tapestry depicting the Adoration of the Kings, to be woven by Morris's Merton Abbey Works for the chapel of Exeter College. "It will be a blaze of color and look like a carol," he said of his plan. The design was a great success, and Morris's firm produced two more versions, one for Eton College Chapel and the other for Norwich Castle. At the request of the Birmingham Corporation, a civic organization, Burne-Jones returned to the subject for a grand-scale watercolor, *The Star of Bethlehem* (1888–91; Plate 44). The plane of paper on which he

Nativity

Plate 43, 1888. Oil on canvas, 81 x 124 in. (205.7 x 315 cm). Carnegie Museum of Art, Pittsburgh; The Heinz Family Fund, 1997.

worked was so vast that Burne-Jones needed a mobile ladder to reach its upper sections. As he painted, he complained about his many trips up and down the ladder, speculating that he had "journeyed as many miles already as ever the kings travelled" (Figure 29). But he also admitted, "I have had a very happy month of autumn, living mostly in the suburbs of Sarras."

The watercolor presents a dreamlike setting of rolling hills and spare trees in which three magnificent kings stand silently before a humble manger. They have

removed their crowns, but their rich raiment proclaims their stations as rulers of distant lands. The first to approach is the eldest king, Gaspar. He has abandoned his crown at his feet, and he opens the jeweled casket in his hands to give the child a gift of gold. Melchoir, armed as a warrior, and Balthasar, in colorfully embroidered robes, wait quietly, holding their tributes of frankincense and myrrh. Burne-Jones followed the venerable tradition of distinguishing the kings by age and race. The Holy Family receives them in quiet dignity. *The Star of Bethlehem* con-

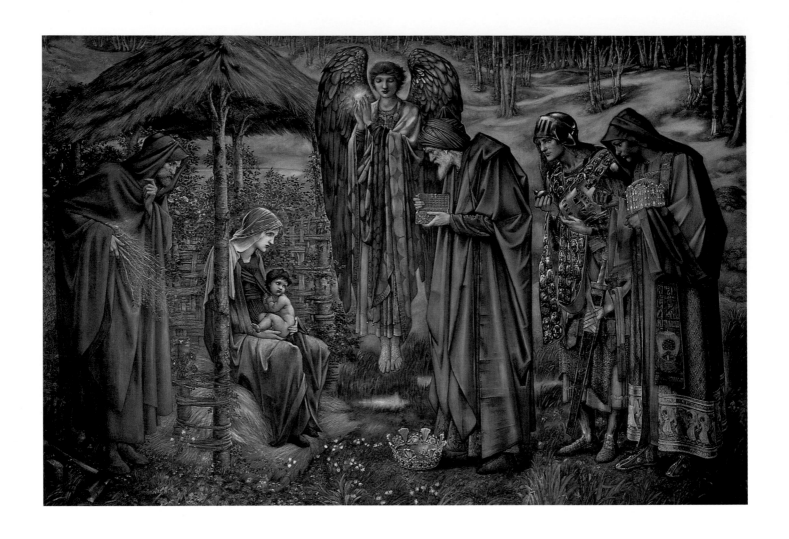

The Star of Bethlehem

Plate 44, 1888–1891. Watercolor, bodycolor, oil, tempera, and gouache on paper, laid onto canvas, 101 x 152 in.
(256.5 x 386.1 cm). Birmingham Museums and Art Gallery.

veys a spirit of reverence and wonder. When asked by a young girl who visited his studio whether he believed in the story, he answered, "It is too beautiful not to be true."

In a letter to Frances Horner, daughter of his patron William Graham, Burne-Jones described the handsome soldier Melchoir and the exotic African Balthasar. But of the eldest king he wrote, "If you like old me (and you can't, no you can't, and you're right) you will like Melchoir." He never tired of joking about his increasing age and feebleness, yet many of his friends would remember him otherwise. The painter and memoirist W. Graham Robertson was a childhood playmate of Margaret Burne-Jones, but he first visited her father's studio as an adolescent. He was at first awed by the tall, solemn painter, with his cool stare and trailing patriarch's beard. As he came to know Burne-Jones, however, he realized that the reverent calm easily gave way to mischief and laughter: "It was like meeting the impish eyes of Puck beneath the cowl

Figure 29, Burne-Jones working on *The Star of Bethlehem,* July 27, 1890. Black-and-white photograph by Barbara Leighton. Courtesy of the National Portrait Gallery, London.

of a monk." To Robertson, the elder artist seemed ageless, with a free and youthful spirit, always ready for flights of fancy, always able to draw upon the clear and vivid imagination "that is usually lost in childhood."

Nonetheless, changes in Burne-Jones's family during the 1880s kept him painfully aware of passing time and mortality. In 1882 he returned from a visit to Birmingham in a state of shock: After almost a half century of life as a

widower, his father had remarried. Four years later his childhood nurse, Miss Sampson, died. In 1889 the aged Jones passed away as well. When Burne-Jones's daughter, Margaret, married in 1888, he felt both joy and sorrow. He liked his new son-in-law, John Mackail, a classical scholar who in 1899 would write the official biography of William Morris's. Even so, Margaret had been his constant companion, sitting with him in the studio, reading to him while he worked, and sharing with him the pranksterish humor that Georgie sometimes found

Seminary for More Advanced Dragonbabies

Figure 30, early 1890s. Pencil, 10 x 7¼ in. (25.4 x 18.4 cm). Courtesy of Sotheby's, London.

schools for children and animals, including the "Seminary for More Advanced Dragonbabies," where the little beasts tumble and wrestle and sleep in the hall before entering classes to study "Hisstry" and "Jogruffy" (Figure 30). Burne-Jones decorated a day nursery for Angela in one of the upper rooms at North End House. On one wall he painted a mill at a pond, and he encouraged her to invent stories about what might happen there. Another wall was kept fresh with whitewash, to receive new paintings made at the child's request and with her

tiresome. The birth of Margaret's daughter, Angela, in 1890 filled that void. Burne-Jones now had another child with whom he could share his dreams and on whom he could lavish his attention.

When the artist visited his granddaughter, he filled pages of a special sketchbook with fantastic drawings of all kinds of fabulous characters. In her memoir of childhood, Angela Mackail Thirkell recalled that even before her second birthday, her grandfather drew any image she demanded, including her raggedy stuffed tiger prowling in a romantic landscape. He created a series illustrating

assistance. He even decorated her scolding corner with the image of a playful kitten, no doubt spoiling the punishment meant to make her contemplate the errors of her ways. When Angela was about two years old, Burne-Jones sat for a set of photographic portraits with her. During the session, she became increasingly restless. He tried to distract her by drawing, but she preferred to amuse herself by pulling his beard, and, as he indulged her, the photographer snapped the shutter (Figure 31).

Burne-Jones's career continued its ascension, despite his doing little to promote himself. In 1889 he was invited

to send a work to the Exposition Universelle in Paris and selected *King Cophetua and the Beggar Maid* (see Plate 32). Despite the urging of his son, Philip, now an aspiring painter, Burne-Jones refused to accompany the work to Paris, claiming he was simply too old. *The Beguiling of Merlin* (see Plate 24), included in the 1878 exposition, had drawn little public attention in France. But *King Cophetua* became a sensation. Hung in the most prominent position in the English Gallery, it earned Burne-Jones the

Figure 31, Burne-Jones and his Granddaughter, c. 1892. Black-and-white photograph. Hammersmith and Fulham Archives and Local History Centre.

Cross of the Legion of Honor. The critics raved about the rich and even bizarre appearance of the work. More than a decade later, the Belgian Symbolist Fernand Khnopff (1858–1921) recalled the painting's hypnotic effect:

> *The scene is incredibly sumptuous: costly stuffs glisten and gleam, luxurious pillows of purple brocade shine in front of chased gold paneling, and the polished metal reflects the beggar-maid's exquisite feet, adorable feet. . . . How perfectly delightful were the hours spent in long contemplation of this work of intense beauty!*

Burne-Jones continued sending works to Paris. In 1891,

on the invitation of Pierre Puvis de Chavannes (1824–1898), he submitted *The Wheel of Fortune* (see Plate 29) to an exhibition at the Champ de Mars. Burne-Jones admired Puvis's solemn and meditative works and was more than pleased to respond to a kindred spirit "who has lifted the same banner." But he responded quite differently to a request from the self-styled magus Joséphin "Sâr" Péladan (1858–1918) to exhibit works at the Salon de la Rose + Croix. Noted for the declaration, "Artist—you are the King! Artist—you are the priest! Artist—you are the Magician," Péladan advocated a mystic vision of art that embraced the decadent and the macabre as well as the beautiful. Burne-Jones feared that Péladan sought a level of intensity that could transform mysterious dreams into feverish nightmares. Not surprisingly, he turned the invitation down, writing to George Frederick Watts: "I don't know about the Salon of the Rose-Cross—a funny high falutin sort of pamphlet has reached me—a letter asking me to exhibit there. . . . [I]t was so silly a piece of mouthing that I was ashamed of it."

Burne-Jones shared with the Symbolists a desire to sim-

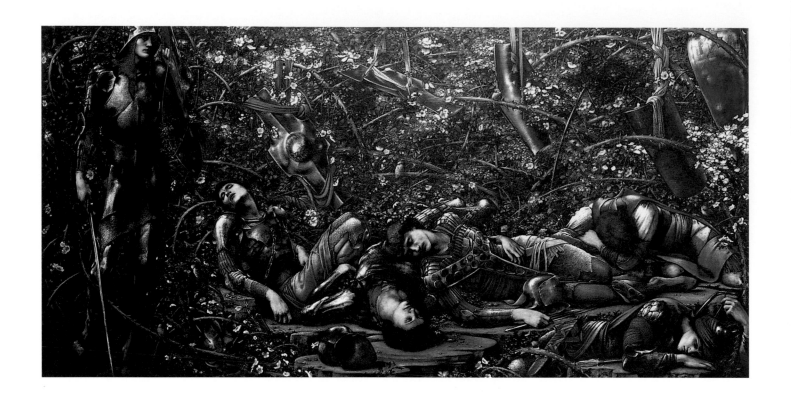

The Briar Rose Series: The Briar Wood

Plate 45, 1870–1890. Oil on canvas, 48 x 98 in. (121.9 x 248.9 cm). Faringdon Collection Trust, Buscot Park.

ulate the state of dreams in art, but his belief in the sanctity of that state separated him from them. Unlike the Symbolists, who dared to penetrate the dark corners of the mind for enlightenment, Burne-Jones purposely refrained from probing too deeply into the mysteries that captivated his imagination. Like the kings and shepherds following the Star in the East or Galahad seeking the Grail, he placed faith in simple disclosure. To see was to believe. He chose not to specify what the vision revealed, preferring to evoke the state of awe that precedes revelation.

His abiding fascination with the wonder of dreams found a perfect subject in the legend of the Briar Rose, in which a mysterious spell plunges a princess and her court into a century of slumber, ended when she is awakened by a kiss. Although Continental in origin, the Sleeping Beauty tale was well known in England from versions in Charles Perrault's *Histoires et contes du temps passé* (1697, translated into English c. 1729 as *Tales of Passed Times. By Mother Goose*) and Jacob and Wilhelm Grimm's *Kinder- und Hausmärchen* (1812–1815; translated into English in 1823 as *Children's and Household Tales).* Tennyson also interpreted the legend in his 1842 poem "The Day Dream." Burne-Jones first illustrated the subject in a set of 1862 tile designs for the Firm. He returned to it in three paintings produced in 1869 on commission from William Graham: *The Briar Wood,* in which a knight encounters sleeping guards in the forest; *The Council Chamber,* showing the king and his slumbering court;

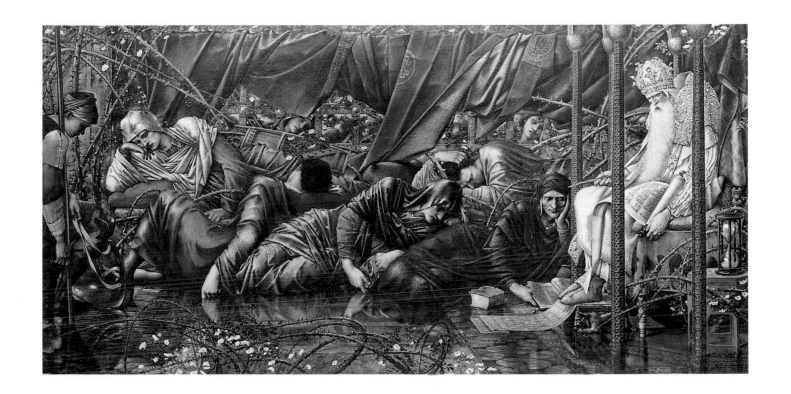

The Briar Rose Series: The Council Chamber

Plate 46, 1870–1890. Oil on canvas, 48 x 98 in. (121.9 x 248.9 cm). Faringdon Collection Trust, Buscot Park.

and *The Rose Bower,* which depicts the princess on her bed, surrounded by her attendants. When these pictures were completed, Burne-Jones immediately began a reprise of the series, almost doubling the size of the images and adding a fourth subject, *The Garden Court,* showing the serving maids asleep outside the princess's chamber.

Burne-Jones worked intermittently on the large *Briar Rose* series in the early 1870s and then set it aside. In the autumn of 1884, he asked his friend Lady Leighton-Warren to send him a branch of the wild rose bush that grew in her garden, "a hoary, aged monarch of the tangle, thick as a wrist and with long, horrible spikes on it." Delighted with the specimen she sent, he returned to

the series with new conviction. As always, his progress was slow and considered. In 1886 Margaret posed for the sleeping princess, and, according to his studio record, he worked regularly on the "Sleeping Palace" pictures, as he called them, for several years, finishing them in April 1890 (Plates 45–48). That summer they were exhibited at Agnew's Gallery in London, through an arrangement Graham had negotiated in 1885, just before his death. Crowds poured in to see them, the *Times* critic voicing the popular opinion that "The world of dreams . . . has surely never been so prodigally illustrated." Alexander Henderson (later Lord Faringdon) purchased the works to be installed in the music salon of his newly purchased Oxfordshire estate, Buscot Park. But before the Briar Rose

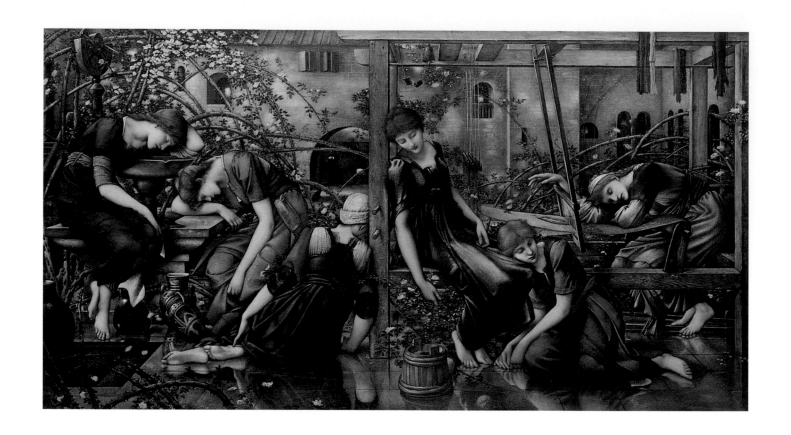

The Briar Rose Series: The Garden Court

Plate 47, 1870–1890. Oil on canvas, 48 x 98 in. (121.9 x 248.9 cm). Faringdon Collection Trust, Buscot Park.

paintings went into private hands, they were shown in a free exhibition at Toynbee Hall in Whitechapel as a gesture of kindness for the poor of East London.

Henderson invited Burne-Jones to see the room where he planned to install the pictures. Enlisting Morris's help, Burne-Jones created a complete interior setting for them, painting ten additional panels to unite the four canvases into a single narrative. Morris also wrote a set of verses that were inscribed on the gilded frames of the main pictures. The finished ensemble, in one of the most beautiful rooms in England, transports the viewer into a dream world. Entering from the drawing room, the first figure to be encountered is the wary knight (Plate 45), who

pauses at the edge of the blooming thicket. He gazes past the slumbering guard, past the sleeping king (Plate 46) and the languid maids (Plate 47). Across the room, as still on her couch as if in death, lies the princess (Plate 48). The inscription on the frame calls to the knight to end the curse, "And smite this sleeping world awake." But all remains still, as the knight stands motionless, suspended in time before seizing his destiny. When asked why he did not carry the cycle to its expected conclusion, Burne-Jones explained, "I want to stop with the Princess asleep and to tell no more, to leave all afterwards to the invention and the imagination of the people, and tell them no more."

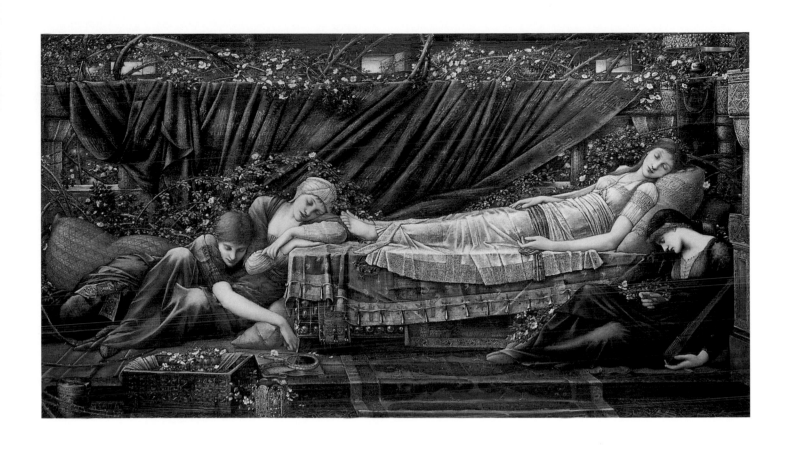

The Briar Rose Series: The Rose Bower

Plate 48, 1870–1890. Oil on canvas, 48 x 98 in. (121.9 x 248.9 cm). Faringdon Collection Trust, Buscot Park.

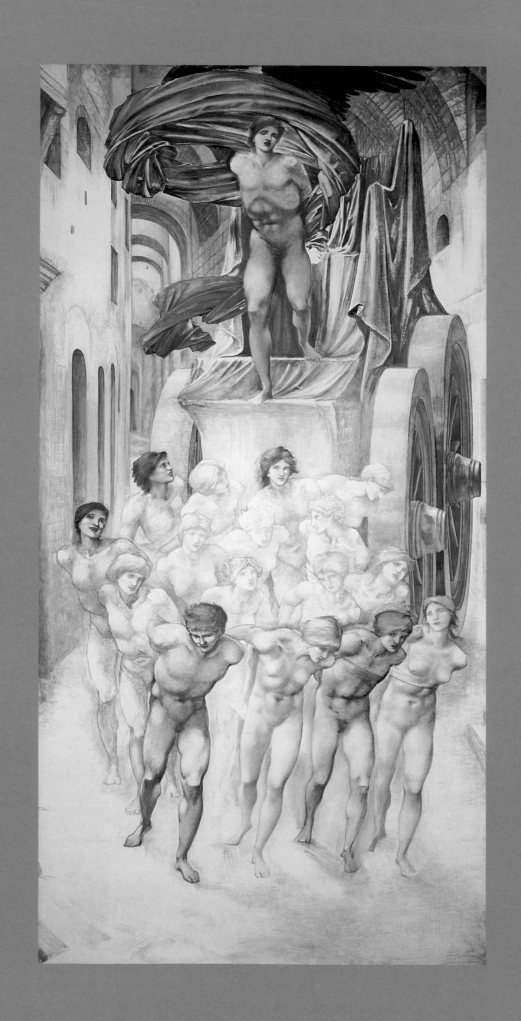

INFINITE REST

As the years passed, Burne-Jones frequently reflected on death. The passing of friends who had influenced him when he was young—Dante Gabriel Rossetti in 1882, Alfred Tennyson in 1892, and Ford Madox Brown in 1893—left him with a sense of irreplaceable loss. Declining health affected many of his other artist friends, including Frederic Leighton and John Everett Millais. Even William Morris's famous vigor began to wane. Burne-Jones's own constitution had never been robust, and in the 1890s he suffered recurring bouts of influenza that often kept him from his work. He also experienced what he called "heart-thumpings," but these were not accompanied by pain or breathlessness, so he attributed them to emotional agitation and relieved them simply by lying down. He took a pragmatic attitude toward mortality: "It's so sad to hear of anyone weeping at the idea of his own death," he observed, adding that, for himself, "It would be infinite rest to no more be worried about doing a picture."

The paintings that crowded his garden studio in the Grange, his London home, were another constant reminder of mortality. He confided to his assistant Thomas M. Rooke that some nights he woke in a state of panic, fearing that the only legacy he would leave his wife and son would be a studio filled with unfinished—and unmarketable—pictures.

But he did nothing to change his habits or increase his sales and spent even more time on uncommissioned works, seeking only to satisfy his own artistic vision. Recalling his visits during the 1890s with Burne-Jones, W. Graham Robertson noted that the gigantic painting *The Car of Love* (Plate 49) dominated one full wall of the studio. Burne-Jones first conceived this image of Cupid, riding triumphantly in a chariot pulled by bound and straining lovers, in 1872; it was the first work on a list he compiled of subjects he "desired to paint above all others." When he returned to the work more than a decade later, the enormous scale of the canvas—fifteen feet tall and six feet wide—demanded grueling labor and limited the potential of finding a buyer. He did not complete the image. Nevertheless, the drama of

FACING PAGE

The Car of Love

Plate 49, begun 1872. Oil on canvas, 180 x 72 in. (457.2 x 182.9 cm). Victoria and Albert Picture Library, London.

the work, with its magnificent figures modeled only in monochrome, dragging the burden of their god and his massive chariot, reveals that, in his late paintings, Burne-Jones attained the grandeur to which he had aspired in earlier years.

Feelings of estrangement from the contemporary art world now plagued him. He despaired of the influence of French modernism on English and American painters, most notably Whistler and John Singer Sargent, and regarded the works of the Impressionists as "muzzy" and unfinished. "They do make atmosphere," he admitted, "but they don't make anything else: they don't make beauty, they don't make design, they don't make idea, they don't make anything but atmosphere—and I don't think that's enough." He confessed to Rooke that he felt like the last practitioner of the type of art that had led him to become an artist, lamenting that:

> It's such a disappointment to find the future of painting turning in that direction. So opposite of all I've wished and thought. . . . When there's an end of me it won't make the slightest difference to what goes on. . . . [W]hen I'm over all that I love will be over and no one will be left to care two straws about it.

Despite his fears of imminent obscurity, the public continued flocking to his exhibitions. After his break with the Grosvenor Gallery in 1887, he regularly sent works to the New Gallery, a venue opened by former Grosvenor co-managers Charles Hallé and J. Comyns Carr. For the winter season of 1892–1893, they mounted a retrospective exhibition of Burne-Jones's paintings, an honor the Grosvenor had failed to grant. Neglect of recognition was

also the factor that led him to resign from the Royal Academy in 1893. He felt that the length and productiveness of his career merited more than Associate status, yet each year's elections had failed to raise him to the rank of full Academician. Other honors came to him, however. In 1894 Queen Victoria bestowed a baronetcy on him, transforming plain Ned Jones from Birmingham into Sir Edward Coley Burne-Jones. But he differentiated public acknowledgment from true appreciation, and it is clear that he would have preferred a grand public commission to a title. "A pity it is I was not born in the middle ages," he complained to Rooke. "People then would have known how to use me."

Working with Morris always renewed his sense of purpose, and in 1892 the friends embarked on a new collaboration. Just one year earlier, Morris had founded the Kelmscott Press, a printing company dedicated to the production of limited-edition, high-quality books. It was Morris's most personal enterprise: He chose the titles and controlled every facet of design, from typeface to page layout. The use of handmade paper, ink blended from lampblack and linseed oil, and hand presses modeled after those used by William Caxton in his fifteenth-century London print shop all guaranteed an alliance of hand craftsmanship and traditional technique that met Morris's uncompromising standards.

Morris wanted his books to be beautiful, featuring rich decorative borders and woodcut illustrations. Burne-Jones designed single illustrations for two of the earliest Kelmscott volumes, Jacobus da Voragine's *The Golden Legend* and Morris's own *A Dream of John Ball*, both printed in 1892.

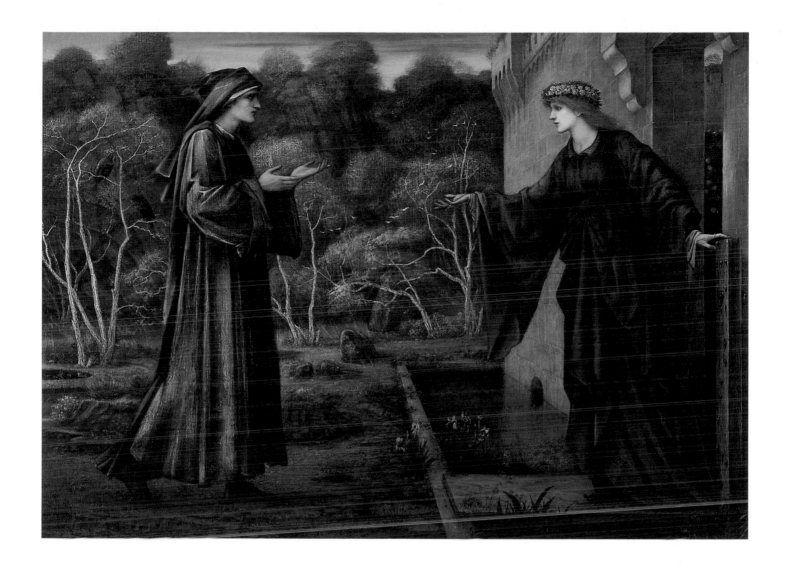

The Pilgrim at the Gate of Idleness

Plate 50, 1884. Oil on canvas, 38 x 51½ in. (96.5 x 130.8 cm). Dallas Museum of Art, Foundation for the Arts Collection, Mrs. John B. O'Hara Fund.

But Morris now proposed to publish the complete works of Geoffrey Chaucer. Using a new typeface created especially for the project and an extensive ensemble of illustrations, decorative borders, and illuminated initials, they would in the Kelmscott Chaucer reach the goal they had been unable to attain in their plans several decades earlier to publish an illustrated folio edition of *The Earthly Paradise*.

From their student days, Burne-Jones and Morris had shared a passion for Chaucer. At Oxford, they read his works together in the Bodelian Library, and Burne-Jones took inspiration from *The Canterbury Tales* in decorating the *Prioress's Tale Wardrobe* (see Plate 2) as a wedding gift for Morris. Morris acknowledged Chaucer as a great influence on his own poetry, most notably in *The Earthly Paradise*, and subjects from Chaucer's works often figured in deco-

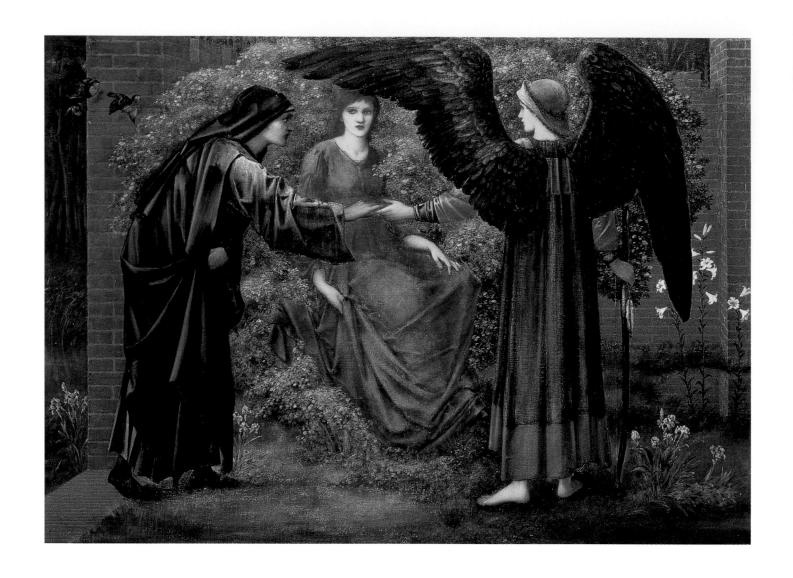

The Heart of the Rose

Plate 51, 1891. Roy Miles Gallery, London/The Bridgeman Art Library International Ltd., London/New York.

rative designs for the Firm. *The Romance of the Rose* inspired one of the first collaborative design efforts by Burne-Jones and Morris for embroidered hangings. In 1874 they created two scenes from Chaucer's allegory for Sir Isaac Lowthian Bell's home, Routon Grange, in Northallerton, Yorkshire, with Burne-Jones designing the figures and Morris, the decorative details. The subject of a pilgrim seeking virtue in the guise of love intrigued Burne-Jones,

who began a series of three paintings based on *The Romance of the Rose.* The first, *The Pilgrim at the Gate of Idleness* (Plate 50), finished in 1884, depicts a moment of temptation, when Idleness, disguised as a comely maiden, attempts to distract the pilgrim from his quest. Again the friends collaborated, with Morris supplying an accompanying verse: "Lo, Idleness opens the gate/ Where through the wandering man awaits/ So many fair and gallant shows/ Born of

the Romance of the Rose." The second in the series, *The Heart of the Rose* (Plate 51), was completed in 1891, but the third, *Love and the Pilgrim*, begun as early as 1877, stood unfinished in his studio for twenty years.

Burne-Jones and Morris prepared for their project by reviving their old custom of reading aloud. Morris gave his friend full liberty to choose subjects to illustrate, and Burne-Jones followed his natural preference for courtly and chivalric scenes. Much to Morris's dismay, he avoided the ribald subjects, noting in the margin of his sketchbook, "No picture to Miller/ no picture to Reeve/ no picture to the Cook's tale." He worked slowly and steadily, constantly teasing Morris that they should toss out their work and begin over. But when Burne-Jones said, "I like a thing perfect," Morris countered with, "I like a thing done." In the end, Burne-Jones produced eighty-seven illustrations, twenty-seven

Figure 32. Page from *The Works of Geoffrey Chaucer: Knight's Tale* (London: Kelmscott Press, 1896). Courtesy of The Newberry Library, Chicago.

more than originally planned. He was curious about what Chaucer would have made of their endeavor: "Now I won-

Figure 33. Title page from *The Works of Geoffrey Chaucer* (London: Kelmscott Press, 1896). Courtesy of The Newberry Library, Chicago.

der, if Chaucer were alive now or if he is aware of what's going on, whether he'd be satisfied with my pictures to his book, or whether he'd prefer impressionist ones."

On June 2, 1896, the first two copies of the completed *Works of Geoffrey Chaucer* were delivered to Burne-Jones and Morris. Burne-Jones gave his copy to his daughter, Margaret, in honor of the birthday she shared with his new grandson, Denis. Both men were pleased with the result of their labors. The rich pages of decoration and illustration, balanced with the text pages of clear, strong print more than met their expectations. Burne-Jones delighted in the way Morris incorporated his individual illustrations into the larger design scheme for each page, surrounding the image with a taut foliate frame, inserting bands of text above and blocks of text below, all bounded by a thick, decorative border. The effect was seamless, as if a single mind had designed the whole. Four hundred twenty-five copies were printed on paper; thirteen were printed on vellum. The book sold well and was widely admired, but it had been so expensive to produce that it was not a financial success. This did not matter at all to either Morris or Burne-Jones; the Kelmscott Chaucer was an endeavor of friendship and faith, not a scheme for profit. As Burne-Jones candidly reflected: "When Morris and I were little chaps at Oxford we should have gone off our heads if such a book came out then, but we have made at the end of our days the very thing we would have made then if we could."

During the last stages of producing the Kelmscott Chaucer, Burne-Jones had noted a decided decline in Morris's health. Late in 1895 he remarked, "I am getting very anxious about Morris and the Chaucer. He has not

Bless Ye My Children

Figure 34, 1896, from an illustrated letter to Margaret Burne-Jones Mackail, May 2, 1896. Ink on paper, 4 x 7 in. (10.2 x 17.8 cm). Inscribed: "this is the nastiest pen that ever was." Special Collections, Bridwell Library, Perkins School of Theology, Southern Methodist University.

done the title page yet. . . . I wish he would not leave it alone any longer." On occasion he discussed his concerns with Rooke, admitting that the loss of Morris would diminish his own life by half.

The year 1896 was one of deep loss for Burne-Jones. Prompted by the deaths of Leighton and Millais, he wrote to his friend Lady Rayleigh, "My friends are dying—one I have lost and one I am losing and I want to make a great

Morris, "seemingly 6 feet high and broad-proportioned—like St. George." But Burne-Jones only remembered the burial as "sweet and touching" and lamented that "there were no kings there—the king was being buried and there were no others left."

One of the few paintings Burne-Jones finished during 1896 expresses a haunting spirit of drained agency. In *Lancelot at the Chapel of the Holy Grail* (Plate 52), the failed and flawed knight collapses outside the sacred chamber that houses the Grail. In the legend, Lancelot's passion for Guenevere barred him from completing his quest. But in

Figure 35, Burne-Jones and Morris, c. 1890. Black-and-white photograph by F. Hollyer and E. Walker. Courtesy of the National Portrait Gallery, London.

fuss over the living and keep them close to me and in sight." In the summer Morris rallied briefly, but during the autumn his friends and family set aside their renewed hopes. Burne-Jones was astonished at his hearty friend's rapid deterioration, lamenting that during one of his last visits Morris was no more than "a shadow . . . a glorious head on a crumple of clothes." On October 3, he died. At the funeral three days later, John Mackail was struck by his father-in-law's noble demeanor; he stood quietly next to Jane

this interpretation, Burne-Jones presents the knight as simply exhausted. The guardian angel at the door, raising his hands in wonder and sympathy, makes no attempt to wake the sleeper; the tale ends in oblivion. Lancelot's enervated posture directly recalls Rossetti's vision of the legendary knight in his 1857 mural design for the Oxford Union. Burne-Jones had been Rossetti's model for Lancelot, and in his portrayal—the knight's lank limbs, fine features, and gaunt grace—there is a poignant tribute to his own lost youth.

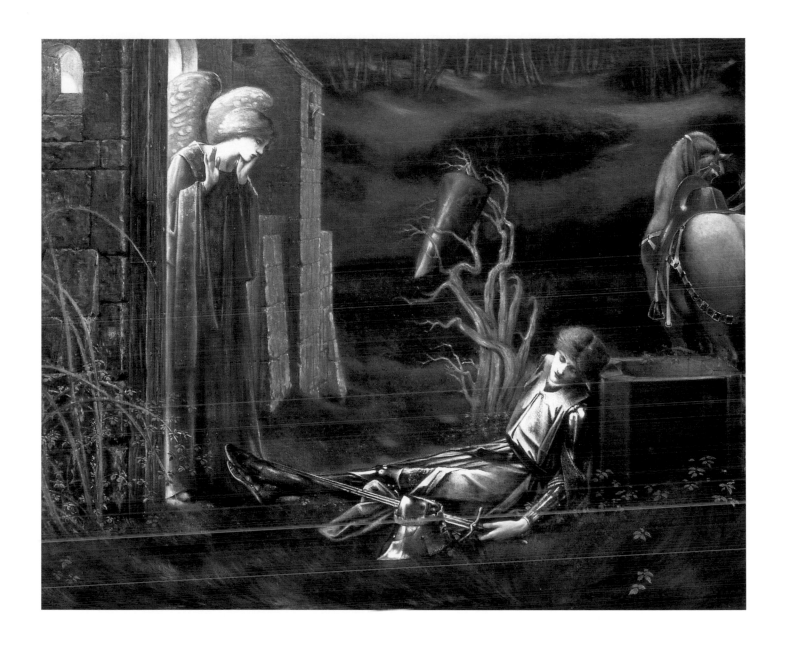

Lancelot at the Chapel of the Holy Grail

Plate 52, 1896. Oil on canvas, 54½ x 66½ in. (138.5 x 169 cm). Southampton City Art Gallery/The Bridgeman Art Library International Ltd., London/New York.

Burne-Jones now increased his efforts to clear his studio of unfinished pictures. He drew inspiration from a comment Morris had made to him only a year earlier: "The best way of lengthening out the rest of our days now, old chap, is to finish off our old things." In the months after Morris's death, he worked steadily on *Love Leading the*

Pilgrim (Plate 53), the last image in his series based on *The Romance of the Rose.* The painting presents the pilgrim making his way hesitantly through a thicket of thorny briar. His guide is a tall, slender, and beautiful youth, crowned with red roses and carrying a pilgrim's staff. This is Love, and he leads the way with bare feet, invulnerable to the

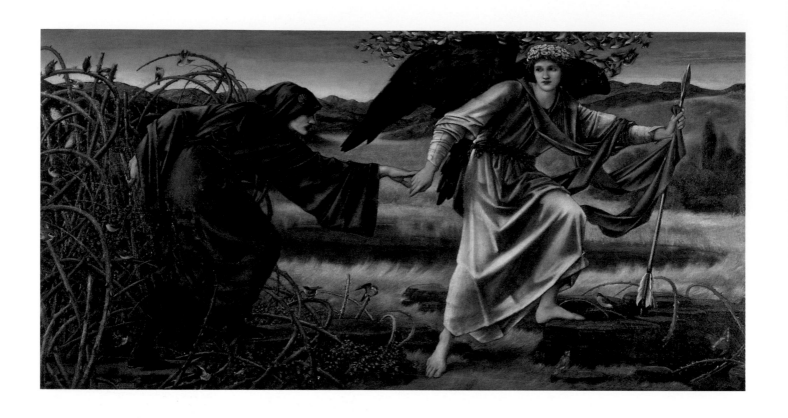

Love Leading the Pilgrim

Plate 53, 1896–1897. Oil on canvas, 62 x 120 in. (157.5 x 304.8 cm). The Tate Gallery, London/Art Resource, N.Y.

wounding stones and brambles in his path. Burne-Jones originally used a dark and gloomy palette for the picture, but his son convinced him to replace the somber tones with a silvery brightness. When the work was exhibited at the New Gallery in 1897, Burne-Jones dedicated it to Algernon Charles Swinburne, the last surviving friend from his days of youthful aspiration. He selected lines from "Tristram of Lyonesse" (1882)—which the poet had dedicated to him—to accompany the entry in the exhibition catalogue: "Love that is first and last of all things made/The light that morning has man's life for shade."

Among the unfinished pictures in his studio was an epic vision of infinite rest. Burne-Jones had begun *The Sleep of Arthur in Avalon* in 1881 as a commission from his friend George Howard, who wanted a large painting for his library

Hill Fairies

Figure 36, c. 1885. Pencil, 11 x 8 in. (27.9 x 20.3 cm). Courtesy of Sotheby's, London.

119

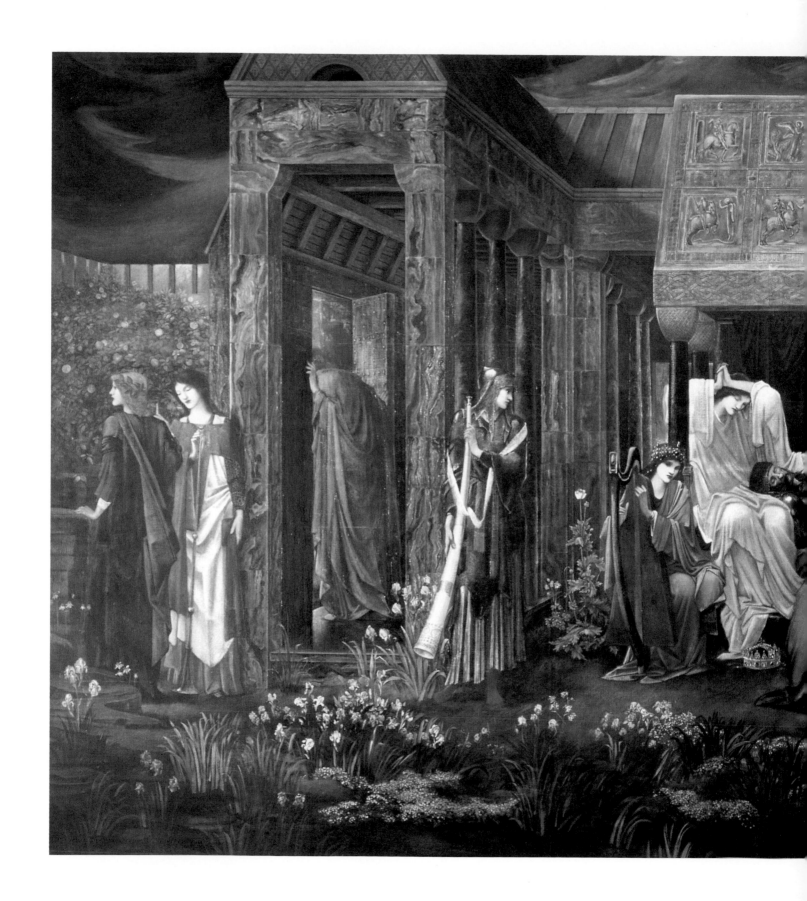

The Sleep of Arthur in Avalon

Plate 54, 1881–1898. Oil on canvas, 111 x 254 in. (281.9 x 645.2 cm). Courtesy of Museo de Arte de Ponce, Puerto Rico.

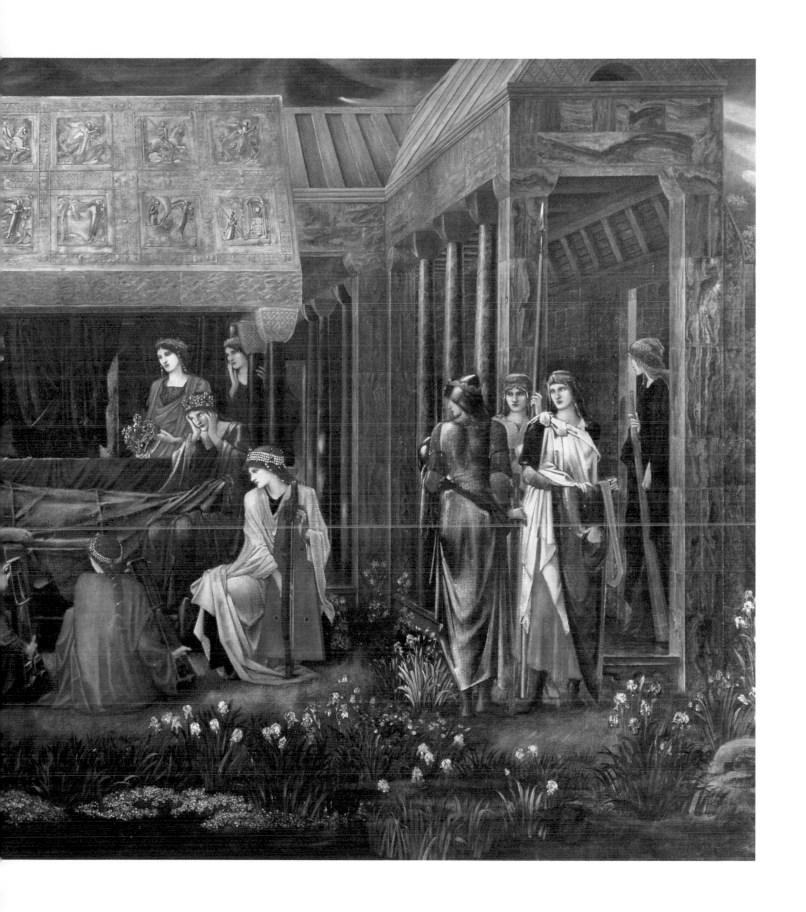

in Naworth Castle, Cumberland. Howard gave Burne-Jones liberty to select a subject from the Arthurian legend, a mutual interest they had held from their earliest acquaintance. The canvas was initially planned as a solemn and conventional depiction of the king at rest after completing his earthly labors. Work progressed slowly until January 1885, when Burne-Jones asked Howard to release him from the obligation. The painting, he explained, now vast in scale— too large for the space intended—was too complex to finish as planned. Moreover, the price he had calculated would never cover his anticipated labor. The artist worried that Howard would be gravely disappointed in his failure to finish the picture: "Then why did I begin it you say. Ah! Why was I begun—who am not really as much worth finishing." He offered to design a simpler scheme, more manageable in size and with fewer figures. He would put aside the original canvas, so that "one day I would finish it, perhaps." Howard generously freed his friend from their agreement and refused return of the advance payment. The alternative design was never realized, but Burne-Jones continued working on the large *Avalon* painting. As Georgie revealed, it became "his own cherished design . . . a task of love to which he put no limit of time and labour." For Burne-Jones, *The Sleep of Arthur in Avalon* was a deeply person-

Meadow Sweet

Plate 55, from *The Flower-Book,* after 1882 (London: 1905). Photo courtesy of The Newberry Library, Chicago.

al testament of commitment to his artistic ideals. Never wanting to exhibit it, and feeling no urgency to finish it, he placed his last stroke upon it on the day before he died.

In order to work comfortably on the outsized canvas, Burne-Jones rented a special studio on Campden Hill Road in London's Kensington district. He continually revised the design. He sketched, then abandoned, panels flanking the central image that featured the figures of Echoes and Hill Fairies, "he-fairies and she fairies, looking ecstatic and silly and very uncombed" (Figure 36). Scenes of battle that stood as a narrative backdrop to the peaceful sanctuary of the sleeping king were also eliminated. He came to concentrate only on the mythic vision of Arthur at rest inside a grand and silent sanctuary, suspended in oblivion until his nation's need would rouse him again.

In *The Sleep of Arthur in Avalon* (Plate 54), the king reclines on a richly draped couch, sheltered in a marble cloister beneath a bronze canopy with gilded plaques that commemorate the quest for the Holy Grail. Seated at his head and feet are the guardian queens, keeping a contemplative vigil. Several attendants play gentle music to soothe their sovereign's slumber, while on the right, noble women bear his arms and his shield. Guards stand ready at the entries to the cloister, holding horns and trumpets

instead of weapons; they will wake the king at the time of his return. In this tranquil atmosphere, safe from harm and disturbance, Arthur enjoys the rest of revitalization. His pain has passed, his wounds are healing. He sleeps content in the knowledge that his former task is concluded and that his future challenge is not yet at hand.

While working on the vast painting, Burne-Jones often referred to the isle of Avalon as an amalgam of place, picture, and his state of mind. In 1886 he wrote a note to Rooke, who was on a sketching tour of Burgundy, coincidentally including a place with the same name as the mythic site: "But how is it you are at Avalon, where I have striven to be with all my might—and how did you get there and how does Arthur the King?. . . I have designed many pictures that are to be painted in Avalon—secure me a famous wall, for I have much to say." As late as 1898, he would forego holidays at Rottingdean to work on the picture, noting in letters to Georgie, "I am *at* Avalon—not yet *in* Avalon" and confessing that "I shall let most things pass me by. I must, if ever I want to reach Avalon." Whenever he turned to other work, he longed only to return to his epic picture. It incorporated the scope of his artistic quest, the ultimate goal of all his imaginative journeys, and it gave him a sense of peace and satisfaction to confide to his friend Lady Leighton-Warren that "My beloved and peerless Morte d'Arthur . . . shall close the tale of me."

In early June 1898, Burne-Jones began reworking the foreground of the picture, covering the field in front of the cloister with a carpet of spring flowers. With Rooke's assistance, he painted columbine, irises, and forget-me-nots among densely clustered blossoms of pink, white, and pale purple meadow sweet. He had used meadow sweet, the traditional symbol of uselessness, in *The Flower-Book*, illustrating it as Arthur's arrival in Avalon at the end of his final battle (Plate 55). He painted a single white poppy at the head of Arthur's couch, an emblem of the consolation found in sleep. He then told Georgie that the picture seemed to be finished. But on June 16 he proposed yet another revision, to remove the red apples that now seemed incongruous when juxtaposed with the bounty of spring flowers.

In the early hours of June 17 Georgie was awakened by her husband's call over the speaking tube that connected their bedrooms. She went to his side, only to watch helplessly as a fatal seizure of angina pectoris ended his life. In the morning, when their children came to join her, she opened the shutters to let in the light and was struck by the serenity that had come over him.

A memorial service was held on June 23 at Westminster Abbey. Georgie had honored his long-standing wish for a modest and private burial three days earlier. His remains were cremated and his ashes interred near the wall of a small churchyard in Rottingdean, adjacent to windows that he had designed and Morris had constructed. For Edward Burne-Jones, Thanatos was a delivering angel, and he left the world in peace. He had lived a life of wondrous imagination, charting his quest in his paintings as he journeyed through his own land of dreams.

Suggested Reading

The following list contains a representative sampling of works that place the life and career of Edward Burne-Jones in the context of the Victorian art world. Georgiana Burne-Jones's 1904 memoir and the unpublished manuscripts noted here are contemporary accounts of the artist. Quotations used in the main text were derived from these sources.

Manuscript Collections (United Kingdom)

Burne-Jones, Edward, and Georgiana Burne-Jones. Letters to George and Rosalind Howard. Castle Howard Archives, Castle Howard, York.

Burne-Jones, Edward. Papers. Department of Manuscripts, Fitzwilliam Museum, Cambridge.

Rooke, T. M. "Notes of Conversations among the Pre-Raphaelite Brotherhood." National Art Library, Victoria and Albert Museum, London.

Published Works

Arts Council of Great Britain. Burne-Jones: The Paintings, Graphic, and Decorative Work of Sir Edward Burne-Jones, 1833–98. exh. cat. London: Arts Council of Great Britain, 1975.

Ash, Russell. Sir Edward Burne-Jones. New York: Harry N. Abrams, 1993.

Baldwin, A. W. The Macdonald Sisters. London: Peter Davies, 1960.

Bell, Malcolm. Edward Burne-Jones: A Record and Review. London: George Bell and Sons, 1892.

B-J, G [Lady Georgiana Burne-Jones]. Memorials of Edward Burne-Jones. 2 vols. London: Macmillan, 1904.

Cecil, David. Visionary and Dreamer. Two Poetic Painters: Samuel Palmer and Edward Burne-Jones. Princeton, N.J.: Princeton University Press, 1969.

Christian, John. The Last Romantics. The Romantic Tradition in British Art: Burne-Jones to Stanley Spencer. London: Lund Humphries, 1989.

Doughty, Oswald, and John Robert Wahl, eds. Letters of Dante Gabriel Rossetti. 4 vols. Oxford: Clarendon Press, 1960.

Fitzgerald, Penelope. Edward Burne-Jones: A Biography. London: Hamish Hamilton, 1975.

Harrison, Martin, and Bill Waters. Burne-Jones. New York: G. P. Putnam's Sons, 1973.

Lago, Mary, ed. Burne-Jones Talking: His Conversations 1895–1898, Preserved by His Studio Assistant Thomas Rooke. London: John Murray, 1981.

Mackail, J. W. The Life of William Morris. London: Longmans, Green and Co., 1899.

MacCarthy, Fiona. William Morris: A Life for Our Time. New York: Alfred A. Knopf, 1995.

Marsh, Jan. Pre-Raphaelite Sisterhood. London: Quartet Books, 1985.

Morgan, Hilary. Burne-Jones, the Pre-Raphaelites and Their Century. 2 vols. London: Peter Nahum, 1989.

Newall, Christopher. The Grosvenor Gallery Exhibitions: Change and Continuity in the Victorian Art World. Cambridge, England: Cambridge University Press, 1995.

Parry, Linda, ed. William Morris. exh. cat. London: Trustees of the Victoria and Albert Museum, 1996.

Robertson, W. Graham. Life Was Worth Living. New York: Harper and Brothers, 1931.

Robinson, Duncan. William Morris, Edward Burne-Jones and the Kelmscott Chaucer. London: Gordon Fraser, 1982.

Spalding, Frances. Magnificent Dreams: Burne-Jones and the Late Victorians. New York: E. P. Dutton, 1978.

Swinburne, Algernon Charles. The Poems of Algernon Charles Swinburne. 6 vols. London: Chato and Windus, 1905.

Tate Gallery. The Pre-Raphaelites. exh. cat. London: Tate Gallery, 1984.

Warner, Malcolm. The Victorians: British Painting, 1837–1901. exh. cat. Washington, D.C.: Board of Trustees of the National Gallery of Art, 1996.

Wildman, Stephen, ed. Visions of Love and Life: Pre-Raphaelite Art from the Birmingham Collection, England. Alexandria, Va.: Art Services International, 1995.

Wood, Christopher. The Pre-Raphaelites. New York: Viking Press, 1981.

Wood, T. Martin. The Drawings of Sir E. Burne-Jones. London: George Newnes, 1906.

INDEX OF PLATES

INDEX OF FIGURES